Advance praise for *"What's So Great About Art, Anywa*

"Branham carefully weaves together a sturdy graphic novel, the log of an intellectual odyssey, and the yummy memoir of a young person making her wobbly way toward teaching into a single comic masterpiece."

— From the foreword by William Ayers

"In the era of No Child Left Behind, the arts were left behind, treated as a luxury, or worse, an obstacle to success: With a contagious passion, a dynamic pen, and a generous wit, Rachel Branham returns art to its rightful place in our schools – the beating heart of the education our children deserve. 'What's So Great About Art, Anyway?' isn't just for educators; it's for all of us."

—Adam Bessie, co-author of graphic report *The Disaster Capitalism Curriculum: The High Price of Education Reform* (with Dan Archer); professor of English, Diablo Valley College

"This visually and conceptually captivating book blazes new territory in the tradition of teacher memoirs, while reminding us of the vital importance of art education in our schools."

—Gregory Michie, Chicago teacher, author of *Holler If You Hear Me*

"This book is refreshing! Branham's ideas are purposefully provocative, and she expresses them through a popular medium."

—Laurel Campbell, Indiana University-Purdue University Fort Wayne

"The author's art style is intriguing. I found myself wanting to read every word and look at every picture. Branham is humorous and inviting, self-deprecating but maintains a strong voice."

—Michael Bitz, founder, The Comic Book Project

"Don't be fooled. This is not just a book for art educators – it's a graphic and entertaining gift to every teacher of children. Based on Rachel Branham's practice and knowledge of the field, as only an art teacher could do it, this book is perfect for every new (and veteran) teacher."

— Fred Klonsky, retired public school art teacher, activist, and blogger (at FredKlonsky.com)

"Rachel Branham has created a practical, thought-provoking, and fun read sure to inspire new teachers and seasoned educators to explore fresh ways of learning alongside their students."

—Nick Sousanis, comics artist and author of *Unflattening*; assistant professor of Humanities & Liberal Studies, San Francisco State University

"Branham provides timely insight into the ongoing evolution of the U.S. educational system. I would share this book with any high school senior who is considering a career in art education."

—Julia Lang-Shapiro, director of Media, Visual, and Performing Arts, Long Beach Public Schools

SELECTED TITLES

Teachers College Press
TEACHERS COLLEGE | COLUMBIA UNIVERSITY
NEW YORK AND LONDON

Published by Teachers College Press, 1234 Amsterdam Avenue, New York, NY 10027

Copyright © 2016 by Teachers College, Columbia University

Cover design by Rachel Branham

Library of Congress Cataloging-in-Publication Data

Names: Branham, Rachel.
Title: What's so great about art, anyway?: a teacher's odyssey / Rachel Branham; foreword by William Ayers.
Description: New York: Teachers College Press, 2016. | Series: Teaching for social justice series | Includes bibliographical references.
Identifiers: LCCN 2016028259 (print) | LCCN 2016028471 (ebook)
ISBN 9780807757321 (pbk.: alk. paper) | ISBN 9780807775035 (ebook)
Subjects: LCSH: Art- Study and teaching.
Classification: LCC N350 .B73 2016 (print) | LCC N350 (ebook)
DDC 700.71–dc23
LC record available at https://lccn.loc.gov/2016028259

ISBN 978-0-8077-5732-1 (paper)

ISBN 978-0-8077-7503-5 (ebook)

Printed on acid-free paper

Manufactured in the United States of America

23 22 21 20 19 18 17 16 8 7 6 5 4 3 2 1

For Cassie Kuzda

Contents

Foreword

"**What's So Great About Art, Anyway?**" Great question. And while there are no **easy** or straight-forward answers, the **provocative**, often surprising reflections in this delightful graphic novel will challenge all **teachers** and prospective educators to think more deeply about their practice—the **craft**, the **science**, and, yes, *the art of teaching*.

And art is the heart of the matter—teaching art and arts education to be sure, but mostly teaching **as** an art, and specifically what the arts can tell us, finally, about teaching **free** people.

The qualities that are stimulated and unleashed in any serious encounter with the arts—**curiosity**, **imagination**, **critical investigation**, **initiative**, **problem-solving**, **improvisation**—are in fact the arts of **liberty**, the very values and conditions necessary for full participation in a democratic society. Artful teaching goes deep and taps this common core; it involves experimentation, observation and analysis, practice and reflection and **surprise**—indeed, the **discovery** and **construction** of a self and the world. Teaching at its best urges voyages.

Branham carefully weaves together a sturdy graphic novel, the log of an **intellectual odyssey**, and the **yummy** memoir of a young person making her way toward teaching into a single comic masterpiece. It's in **part** a **detailed** and **practical** manual, and in **part** an invitation to **dive into the vortex** and paddle alongside Rachel Branham toward enlightenment and **liberation**.

It's also something of a **manifesto**, a declaration of independence, a set of demands to tack onto the heavy oak doors of **power**, and a program to mobilize the troops—students, **parents**, **teachers**, community folks—in order to **storm** the heavens and **demand** the schools we deserve. **We** insist that teaching be built on our basic human need to build and **create**, to perform and construct, to speak up and act out.

Art matters!

—William Ayers

Acknowledgments

I wish to offer my sincerest gratitude to Peter Sclafani, Karl Nyberg, Carole Saltz, Bill Ayers, and everyone at Teachers College Press for bringing this book to life. Thank you for providing me with this opportunity to share my joys and angsts with the world.

I want to thank my cohorts, peers, and professors at the Rhode Island School of Design, The Ohio State University, the Columbus College of Art and Design, and every school in which I've had the privilege to work, without whom my professional and personal identities would not exist.

Special thanks to my incredible husband, my supportive family, and my amazing friends.
 Thanks for putting up with me.

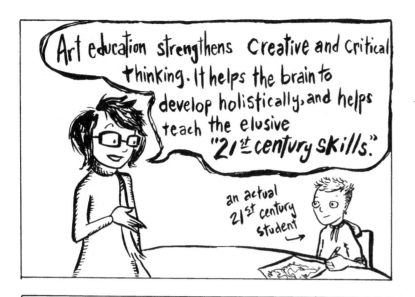

Art education strengthens creative and critical thinking. It helps the brain to develop holistically, and helps teach the elusive "21st century skills."

an actual 21st century student →

As we move even further into the new millennium, it has become increasingly valuable for our children to do more than previous generations were asked:

to reinvent, re-imagine, reconstruct, and solve the problems we've created by thinking so simplistically.

—GULP!

Therein lies the goal of the mysterious "21st century skills."

But... what are they, exactly?

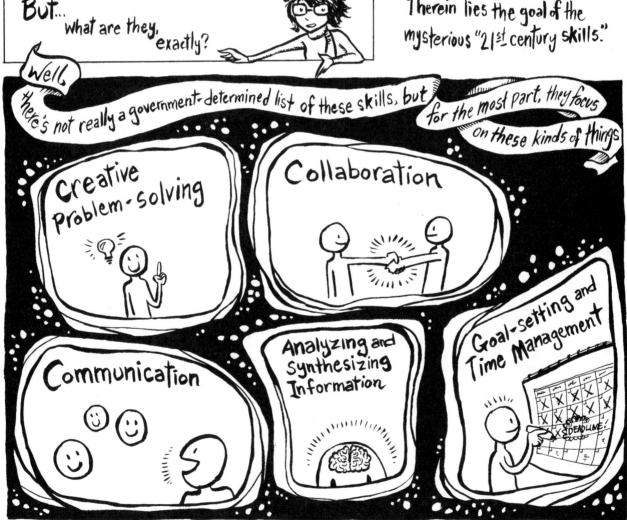

Well, there's not really a government-determined list of these skills, but for the most part, they focus on these kinds of things.

Creative Problem-Solving

Collaboration

Communication

Analyzing and Synthesizing Information

Goal-setting and Time Management

DEADLINE!

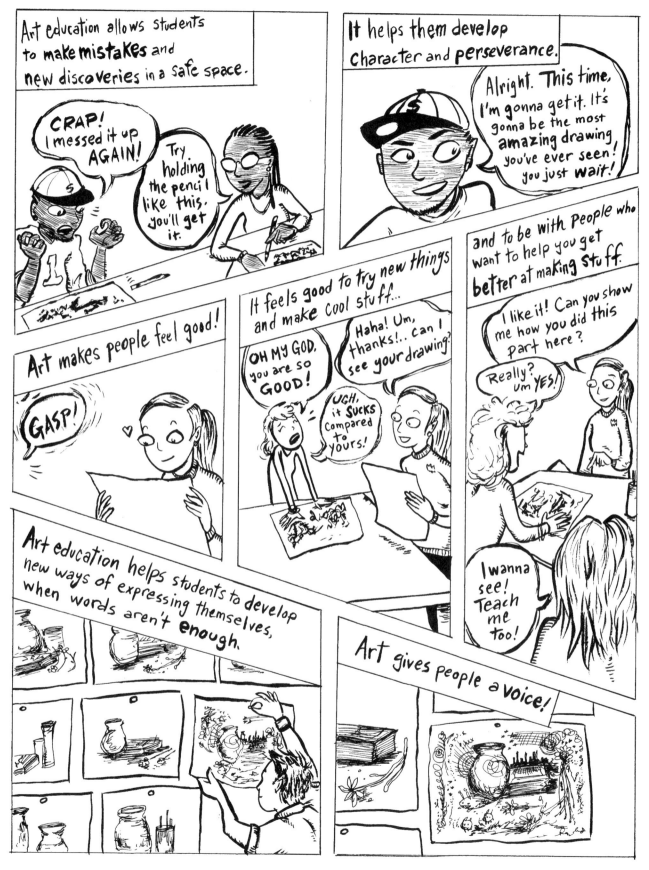

See what I mean?

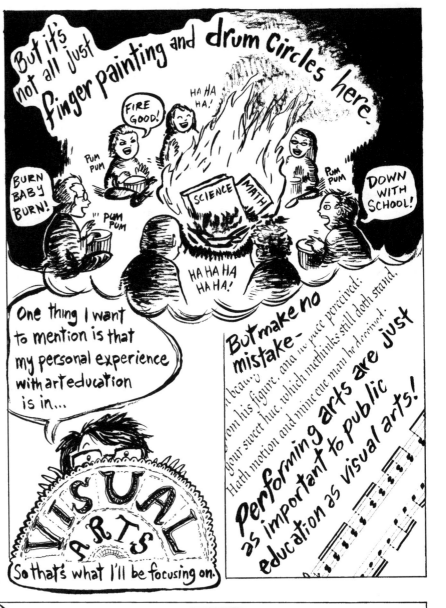

But it's not all just finger painting and drum circles here.

FIRE GOOD!

HA HA HA!

BURN BABY BURN!

PUM PUM

PUM PUM

"' PUM PUM

HA HA HA HA HA!

SCIENCE

MATH

PUM PUM

DOWN WITH SCHOOL!

But make no mistake—

A beauty, and no face perceived: from his figure, and no face perceived: your sweet hue, which methinks still doth stand. Hath motion and mine eye may be deceived,

performing arts are just as important to public education as visual arts!

There's a whole lot of other stuff that's really important and worth talkin' about.

One thing I want to mention is that my personal experience with art education is in...

VISUAL ARTS

So that's what I'll be focusing on.

I'll also be using a lot of **educational jargon**, but don't worry! It becomes less confusing after a while...

(or when in doubt, assume the word is an acronym for a test or something).

Ready? Let's get going!

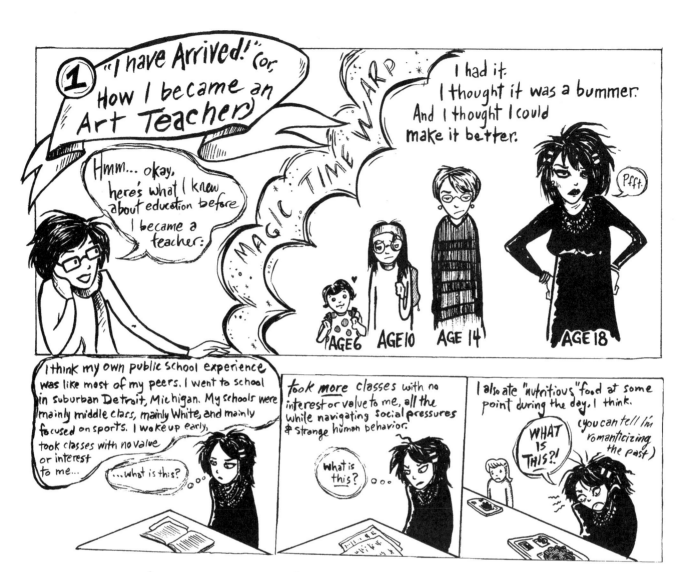

① "I have Arrived!" (or, How I became an Art Teacher)

MAGIC TIME WARP

Hmm... okay, here's what I knew about education before I became a teacher:

I had it. I thought it was a bummer. And I thought I could make it better.

Pfft.

AGE 6 AGE 10 AGE 14 AGE 18

I think my own public school experience was like most of my peers. I went to school in suburban Detroit, Michigan. My schools were mainly middle class, mainly White, and mainly focused on sports. I woke up early, took classes with no value or interest to me...

...what is this?

took more classes with no interest or value to me, all the while navigating social pressures & strange human behavior.

what is this?

I also ate "nutritious" food at some point during the day. I think.

WHAT IS THIS?!

(you can tell I'm romanticizing the past)

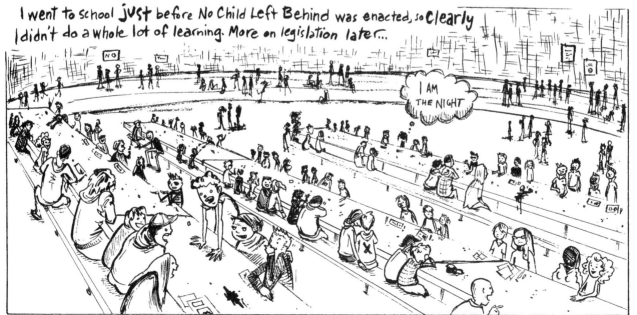

I went to school just before No Child Left Behind was enacted, so clearly I didn't do a whole lot of learning. More on legislation later...

NO

I AM THE NIGHT

My teachers were a regular cast of characters, but I never considered any of them to be a mentor or confidant.

grumble...

School was easy for me, but also really hard.

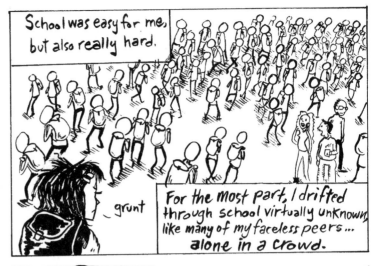

grunt

For the most part, I drifted through school virtually unknown, like many of my faceless peers... **alone in a crowd.**

It was easy for my teachers to leave me be, since I managed to keep my grades up without making a fuss.

I attribute this to my "Protestant work ethic" and **a deeply** instilled fear of **failure.**

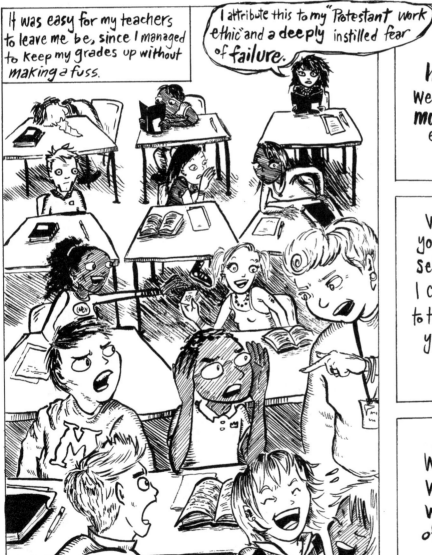

How many of my peers felt this way too? Or how many of my peers were dealing with **even more serious** emotional turmoil?

When you're in school, your universe is small and self-centered. Now I wish I could've seen **past myself** to the **population** of young adults like me.

What were they feeling? What were they thinking? What did **they** want to get out of school?

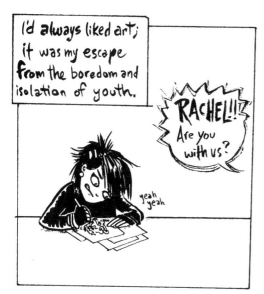

I'd always liked art; it was my escape from the boredom and isolation of youth.

RACHEL!!! Are you with us?

yeah yeah

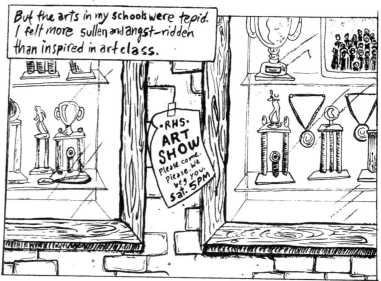

But the arts in my schools were tepid. I felt more sullen and angst-ridden than inspired in art class.

·RHS· ART SHOW Please come. Please, we beg you. Sat. 5PM

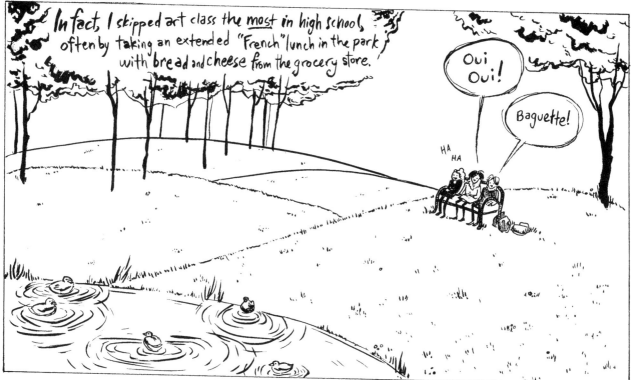

In fact, I skipped art class the most in high school, often by taking an extended "French" lunch in the park with bread and cheese from the grocery store.

Oui Oui!

Baguette!

HA HA

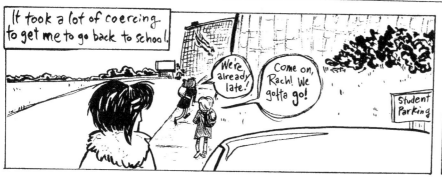

It took a lot of coercing to get me to go back to school!

We're already late!

Come on, Rach! We gotta go!

Student Parking

Personally, I disliked it **SO** much that I found a way to graduate **five months** early... the sooner I could get out, **the better.**

(How's that for sweet irony?)

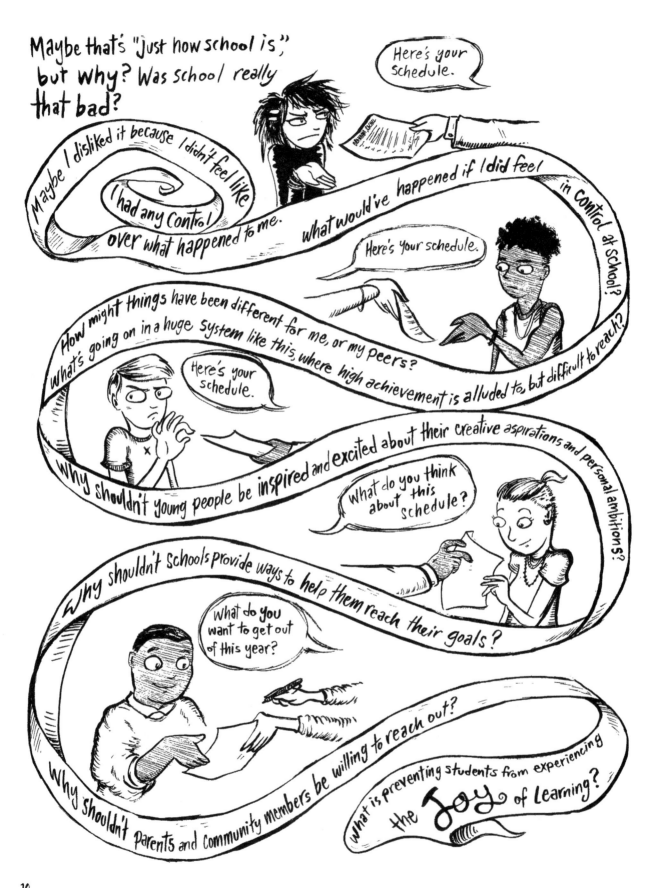

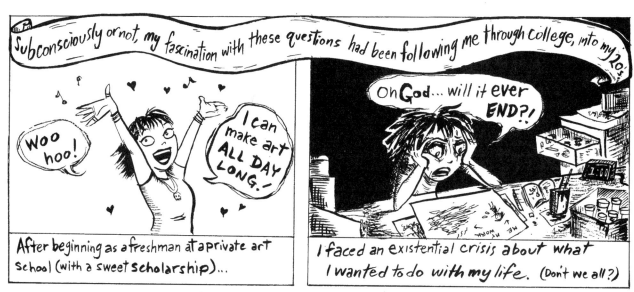

Subconsciously or not, my fascination with these questions had been following me through college, into my 20s.

After beginning as a freshman at a private art school (with a sweet **scholarship**)...

I faced an existential crisis about what I wanted to do with my life. (Don't we all?)

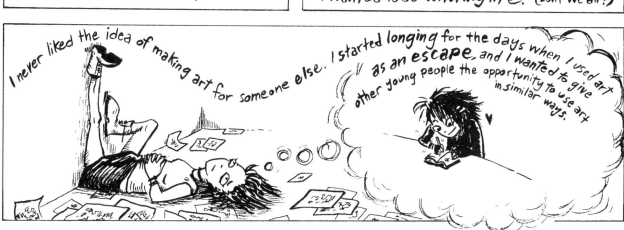

I never liked the idea of making art for someone else. I started longing for the days when I used art as an **escape**, and I wanted to give other young people the opportunity to use art in similar ways.

So I made the switch to an art education program, did my student teaching, and got a job right after graduation.

There I was, thinking that I knew what I was doing! so cute.

That was when the **real** fun started...

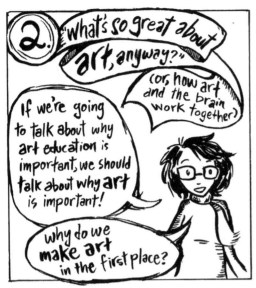

② "What's so great about art, anyway?"

(or, how art and the brain work together)

If we're going to talk about why art education is important, we should talk about why art is important!

Why do we make art in the first place?

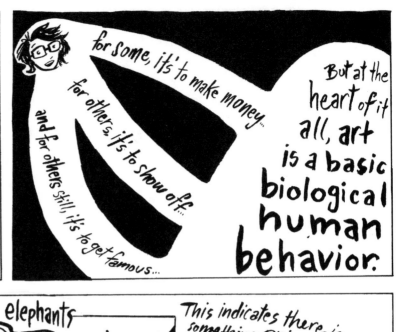

For some, it's to make money...

for others, it's to show off...

and for others still, it's to get famous...

But at the heart of it all, art is a basic biological human behavior.

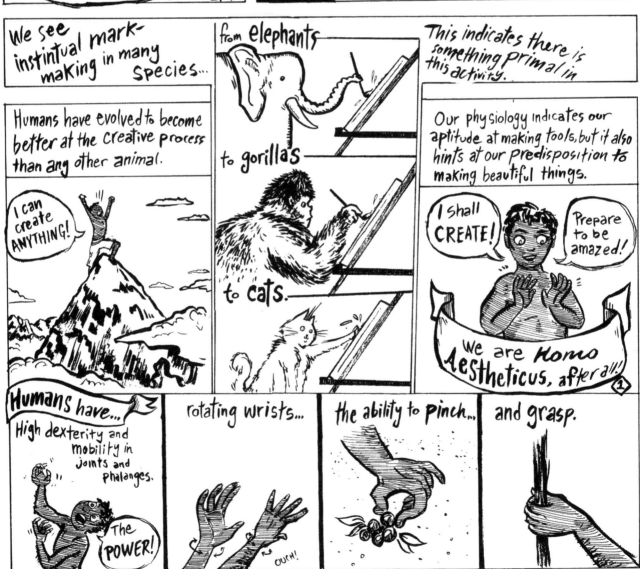

We see instintual mark-making in many species...

Humans have evolved to become better at the creative process than any other animal.

I can create ANYTHING!

from elephants

to gorillas

to cats.

This indicates there is something primal in this activity.

Our physiology indicates our aptitude at making tools, but it also hints at our predisposition to making beautiful things.

I shall CREATE!

Prepare to be amazed!

We are Homo Aestheticus, after all!!!

Humans have...

High dexterity and mobility in joints and phalanges.

The POWER!

rotating wrists...

OUCH!

the ability to pinch...

and grasp.

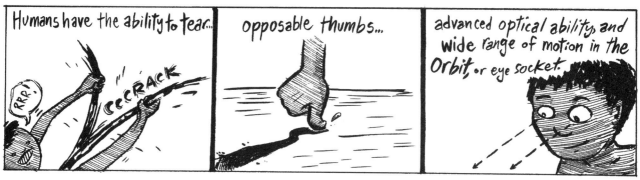

Humans have the ability to tear...

opposable thumbs...

advanced optical ability, and wide range of motion in the orbit, or eye socket.

Humans have highly developed hand-eye coordination...

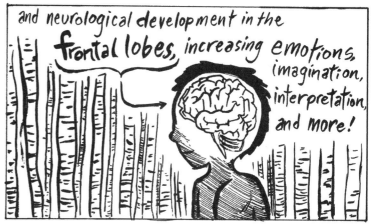

and neurological development in the frontal lobes, increasing emotions, imagination, interpretation, and more!

As we are designed... to make tools, so too do we build and create!

How does your brain solve problems? How does your brain adapt to new situations?

How does your brain retain information? Where are my car keys?

The answers are *hard to explain*, but exist within the interactions of your two brain hemispheres: the **Left** and the **Right**.

(my car keys were in my pocket the whole time)

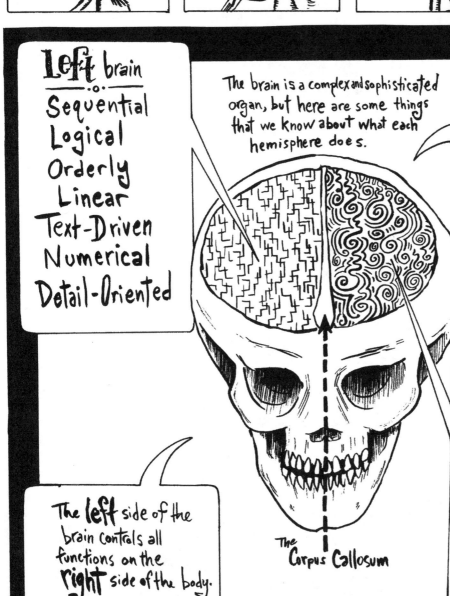

Left brain
- Sequential
- Logical
- Orderly
- Linear
- Text-Driven
- Numerical
- Detail-Oriented

The brain is a complex and sophisticated organ, but here are some things that we know about what each hemisphere does.

The right brain controls all functions on the **left** side of the body.

The Corpus Callosum

The **left** side of the brain controls all functions on the **right** side of the body.

Right brain
- Simultaneous
- Emotional
- Disorderly
- Non-Linear
- Image-Driven
- Contextual
- Big Picture

There have been studies suggesting that these hemispheres don't explicitly control these ways of thinking...

But to me, it's worth mentioning, because I feel it reflects the **compartmentalized** "either/or" mentality we bring to education...

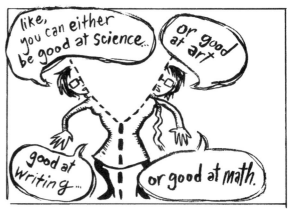

like, you can either be good at science...

or good at art

good at writing...

or good at math.

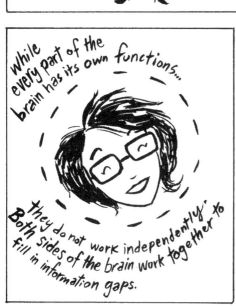

While every part of the brain has its own functions...

they do not work independently. Both sides of the brain work together to fill in information gaps.

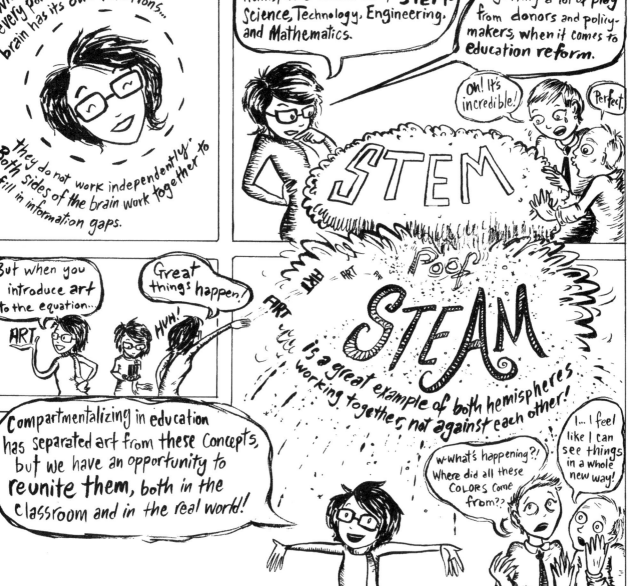

The specializations of the left hemisphere remind me of **STEM**—Science, Technology, Engineering, and Mathematics.

These subjects are getting a lot of **play** from donors and policy-makers, when it comes to **education reform**.

Oh! It's incredible!

Perfect.

STEM

Poof

STEAM is a great example of both hemispheres working together, not against each other!

But when you introduce **art** to the equation...

ART

Great things happen!

HUH!

Compartmentalizing in education has separated art from these concepts, but we have an opportunity to **reunite them,** both in the classroom and in the real world!

w-what's happening?! Where did all these **colors** come from??

I... I feel like I can see things in a whole new way!

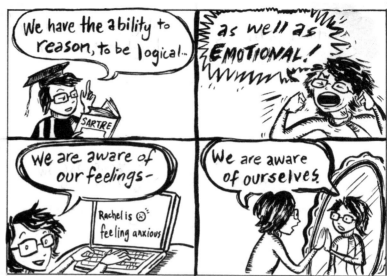

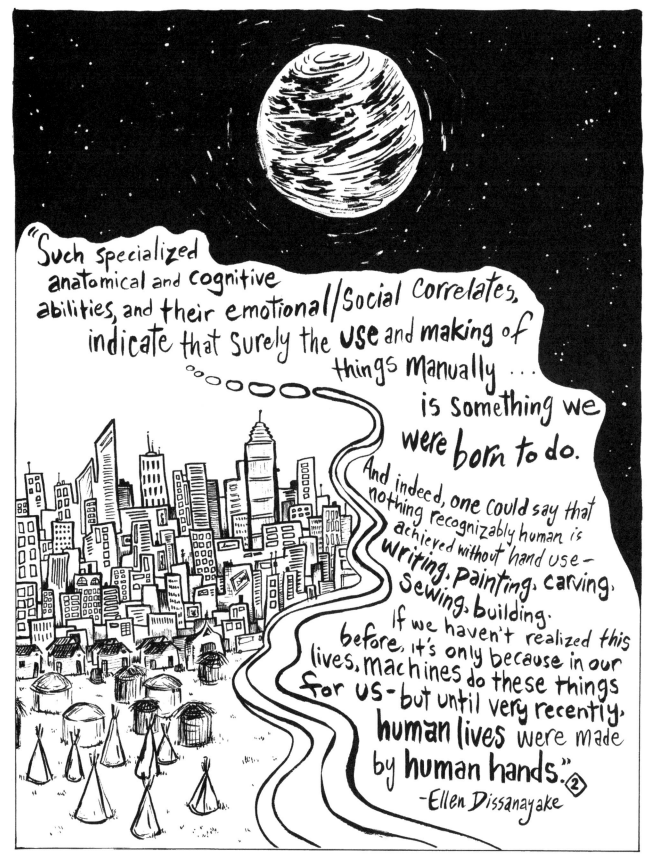

"Such specialized anatomical and cognitive abilities, and their emotional/social correlates, indicate that surely the **use** and making of things manually ... is something we were **born to do.**

And indeed, one could say that nothing recognizably human is achieved without hand use— **writing, painting, carving, sewing, building.** If we haven't realized this before, it's only because in our lives, machines do these things for us—but until very recently, **human lives** were made by **human hands.**" ②
—Ellen Dissanayake

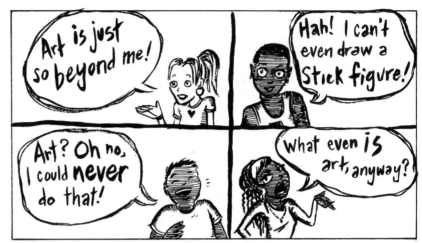

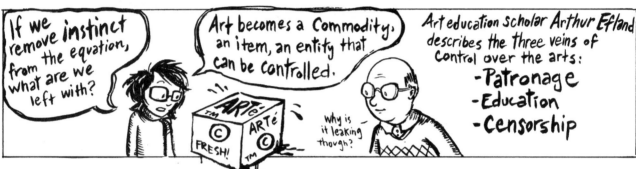

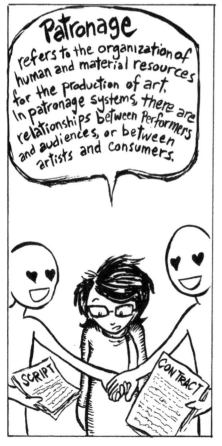

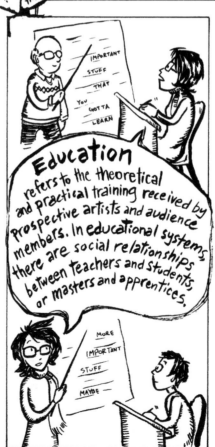

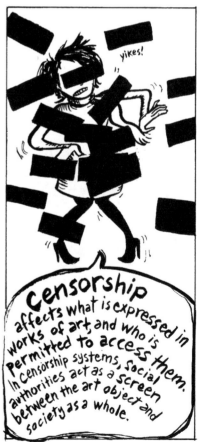

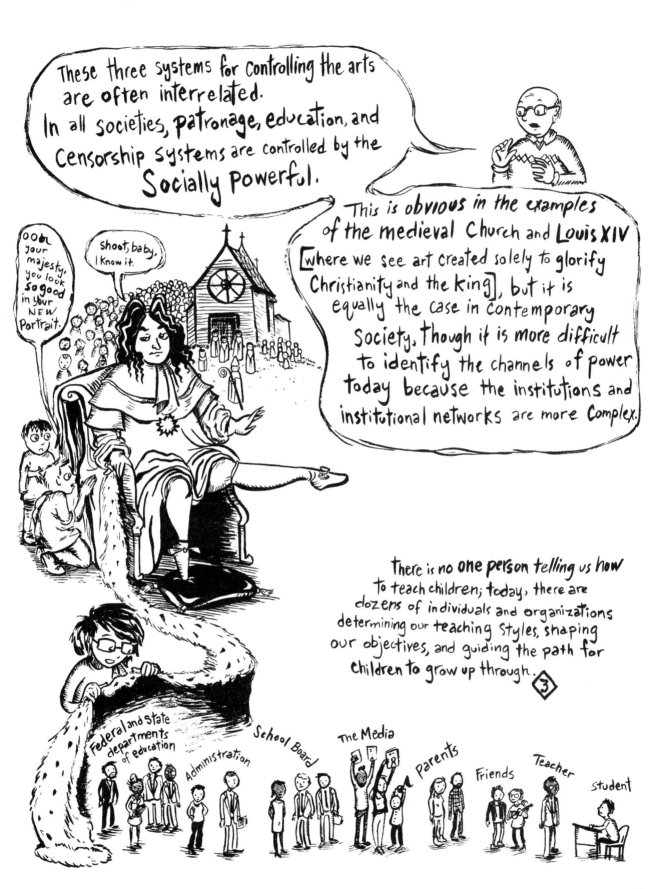

These three systems for controlling the arts are often interrelated. In all societies, **patronage**, education, and censorship systems are controlled by the **Socially Powerful.**

This is **obvious** in the examples of the medieval Church and **Louis XIV** [where we see art created solely to glorify Christianity and the king], but it is equally the case in contemporary society. Though it is more difficult to identify the channels of power today because the institutions and institutional networks are more complex.

oob, your majesty, you look **so good** in your NEW portrait.

Shoot, baby, I know it.

there is no **one person** telling us how to teach children; today, there are dozens of individuals and organizations determining our teaching styles, shaping our objectives, and guiding the path for children to grow up through. ③

Federal and state departments of education

Administration

School Board

The Media

Parents

Friends

Teacher

Student

With this in mind, it's no wonder that our perception of art has changed so much as societies advance.

Art is stupid. This class is stupid. And you're stupid.

I suck at drawing. I suck at art.

I don't even **care** about this class.

("I don't understand what art is and that makes me angry.")

("My previous attempts in visual arts have resulted in **embarrassment**")

("Nobody has ever made me feel confident about my ideas or my artistic abilities.")

Art is one of those things that is seen as completely **exceptional**...

Isn't he wonderful? My child is an **Artist!**

Mom!

or something **frivolous,** and useless.

Yeah, my kid thinks he's some kinda **Artist!** Huh!

Dad!

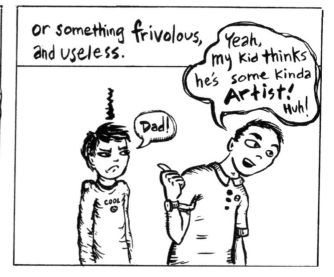

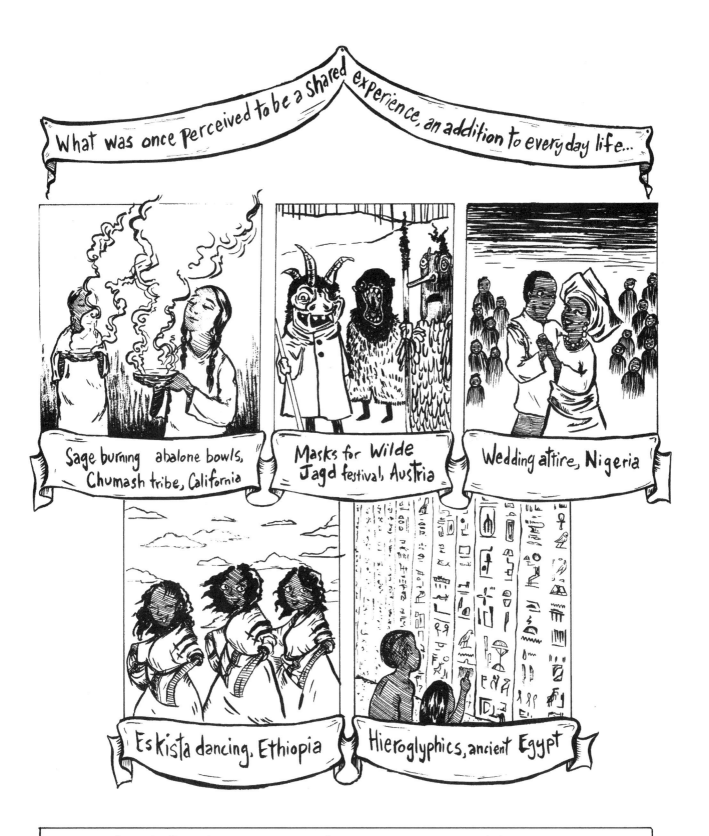

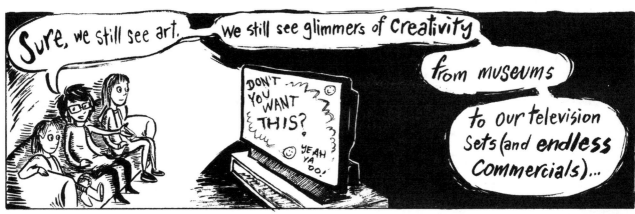

Sure, we still see art. We still see glimmers of creativity from museums to our television sets (and **endless** commercials)...

DON'T YOU WANT THIS?

😊 YEAH YA DO!

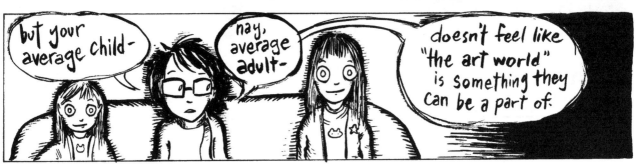

but your average child— nay, average adult— doesn't feel like "the art world" is something they can be a part of.

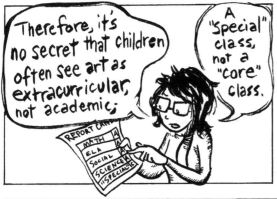

Therefore, it's no secret that children often see art as extracurricular, not academic; A "special" class, not a "core" class.

REPORT CARD
MATH A
ELA A
SOCIAL
SCIENCE
SPECIAL

So for someone who has never felt like art was something they could do, or be involved in, it's difficult to get them involved in it **later in life.**

I... I cannot... I cannot art...

Sometimes, schools are the only places where people are ever exposed to art - brief as it may be! Once the class is over, those who feel like they are still on the outside of art may not find a way back in. We're not professional artists, they say, so what difference does it make?

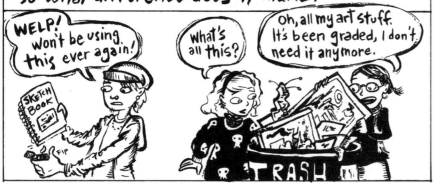

WELP! Won't be using this ever again!

SKETCH BOOK

FLIP

What's all this?

Oh, all my art stuff. It's been graded, I don't need it anymore.

TRASH

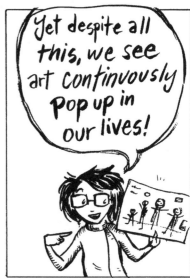

Yet despite all **this**, we see art continuously pop up in our lives!

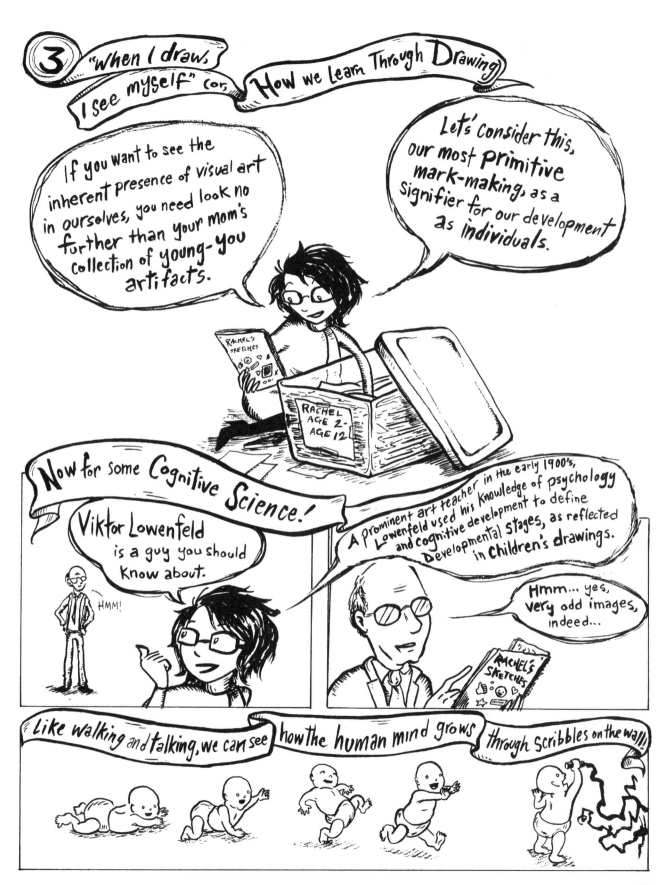

There's the **Scribble** stage first.

Toddlers are still figuring out their **motor activity**, gaining more confidence as they make **more controlled marks.** By the end of this stage, they start **naming** their scribbles — mommy, daddy, puppy, etc.

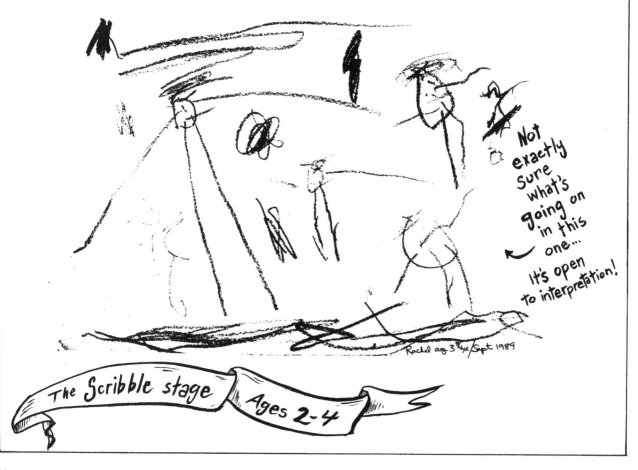

Not exactly sure what's going on in this one...

It's open to interpretation!

Rachel age 3¾yr/Sept 1989

The Scribble stage — Ages 2-4

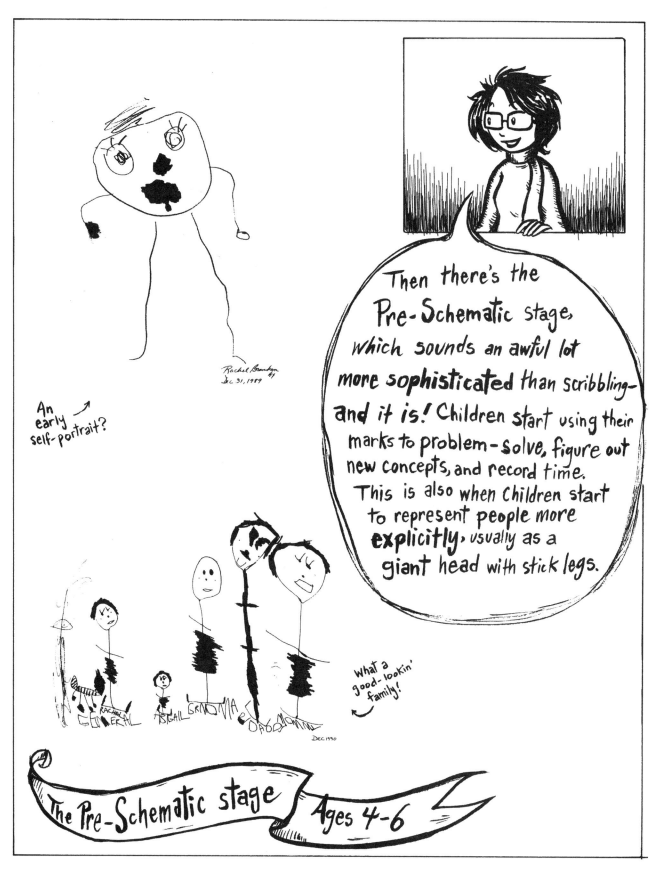

An early self-portrait?

Then there's the Pre-Schematic stage, which sounds an awful lot more **sophisticated** than scribbling- **and it is!** Children start using their marks to problem-solve, figure out new concepts, and record time. This is also when children start to represent people more **explicitly**, usually as a giant head with stick legs.

What a good-lookin' family!

The Pre-Schematic stage Ages 4-6

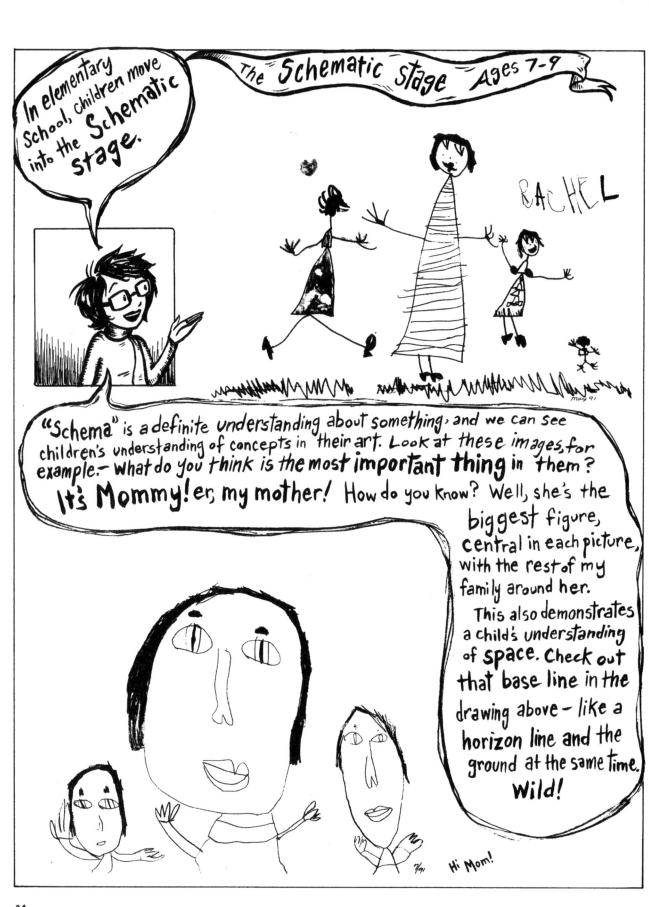

The Schematic Stage — Ages 7-9

In elementary school, children move into the Schematic stage.

RACHEL

"Schema" is a definite understanding about something, and we can see children's understanding of concepts in their art. Look at these images, for example. — What do you think is the most important thing in them? It's Mommy! er, my mother! How do you know? Well, she's the biggest figure, central in each picture, with the rest of my family around her.

This also demonstrates a child's understanding of space. Check out that base line in the drawing above — like a horizon line and the ground at the same time. Wild!

Hi Mom!

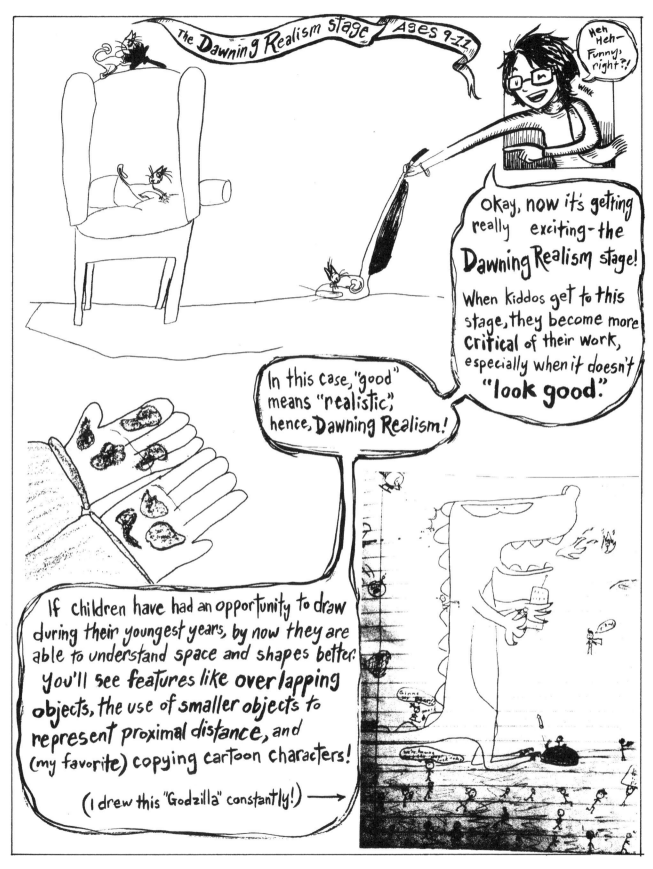

The Dawning Realism stage — Ages 9-12

Heh Heh— Funny, right?! WINK

Okay, now it's getting really exciting— the **Dawning Realism stage!**

When kiddos get to this stage, they become more **critical** of their work, especially when it doesn't **"look good."**

In this case, "good" means "realistic", hence, **Dawning Realism!**

If children have had an opportunity to draw during their youngest years, by now they are able to understand space and shapes better. You'll see features like **overlapping objects,** the use of smaller objects to represent proximal distance, and (my favorite) copying cartoon characters!

(I drew this "Godzilla" constantly!) ⟶

With encouragement, and practice, preteens move into the

Pseudo-Naturalistic stage

Ages 11-13

ooh fancy!

Here we see additional attempts to create realistic and authentic images, with ever-increasing personal scrutiny fueled by hormones and inner turmoil.
(and believe me, I knew about **angst!**)

Techniques like shading, foreshortening, and perspective drawing are introduced. Children become more sensitive to symbolic representation, such as using color to show **emotions.**

My first attempt at inking with a brush!

The Pseudo-Naturalistic stage is **so important** because if children aren't given enough support or opportunity, their creative development can **weaken**, decreasing the likelihood of a child wanting to continue drawing, and moving out of this "crisis" period.

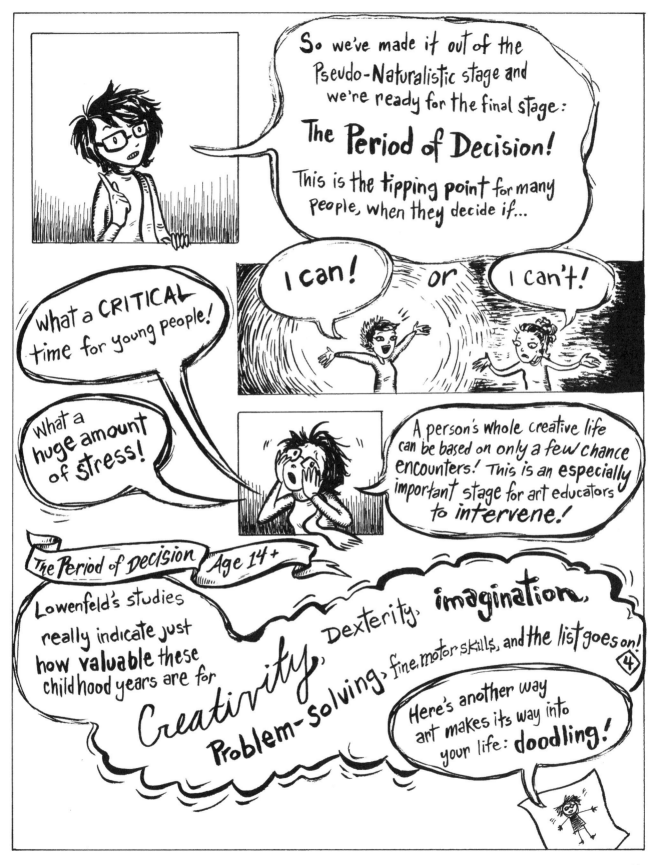

So we've made it out of the Pseudo-Naturalistic stage and we're ready for the final stage:

The Period of Decision!

This is the **tipping point** for many people, when they decide if...

I can!

or

I can't!

What a CRITICAL time for young people!

What a huge amount of stress!

A person's whole creative life can be based on only a few chance encounters! This is an especially important stage for art educators to **intervene!**

The Period of Decision — Age 14+

Lowenfeld's studies really indicate just how **valuable** these childhood years are for

Creativity, Dexterity, *imagination,* Problem-Solving, fine motor skills, and the list goes on! ④

Here's another way art makes its way into your life: **doodling!**

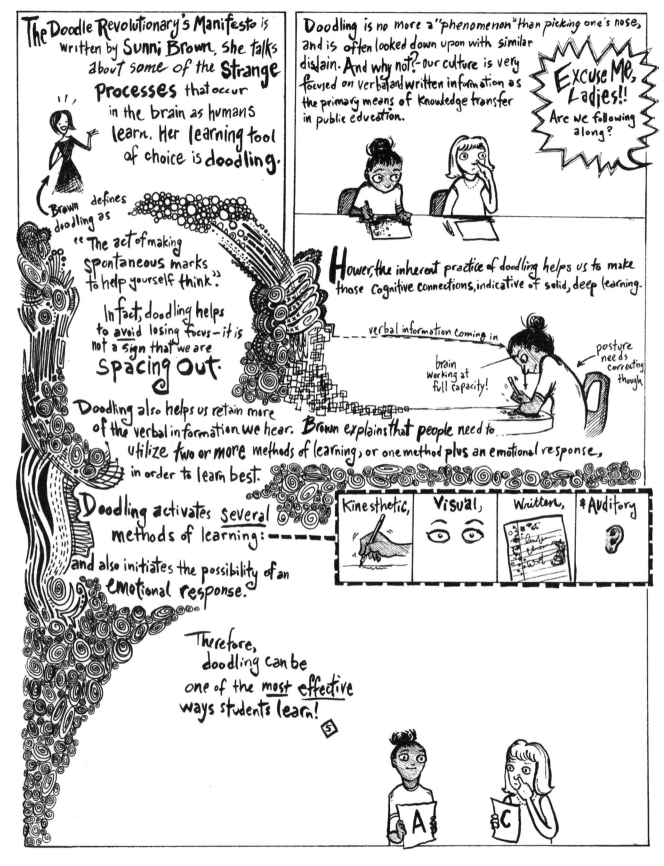

The Doodle Revolutionary's Manifesto is written by Sunni Brown. She talks about some of the Strange Processes that occur in the brain as humans learn. Her learning tool of choice is doodling.

Brown defines doodling as "The act of making spontaneous marks to help yourself think."

In fact, doodling helps to avoid losing focus — it is not a sign that we are SPACING OUT.

Doodling also helps us retain more of the verbal information we hear. Brown explains that people need to utilize two or more methods of learning, or one method plus an emotional response, in order to learn best.

Doodling activates several methods of learning: — — — and also initiates the possibility of an emotional response.

Therefore, doodling can be one of the most effective ways students learn! [5]

Doodling is no more a "phenomenon" than picking one's nose, and is often looked down upon with similar disdain. And why not? — our culture is very focused on verbal and written information as the primary means of knowledge transfer in public education.

Excuse Me, Ladies!! Are we following along?

However, the inherent practice of doodling helps us to make those cognitive connections, indicative of solid, deep learning.

verbal information coming in

brain working at full capacity!

posture needs correcting though

Kinesthetic, Visual, Written, & Auditory

Cartoonist and wonder woman **Lynda Barry's** opinion of doodling is slightly different. Rather than using the doodling Practice as a way to learn, she explains it as an act of meditation, clarifying one's thoughts.

It's especially important for **adults**, or people who may have "given up" on creating art (aka not having moved on from Lowenfeld's Pseudo-Naturalistic stage). She says,

"I believe it's because it helps us maintain a certain Patient state of mind, and there is a part of us that has never forgotten this. In the beginning, it's one of the reasons we draw, though we may never notice this effect with the **thinking part of our minds**." [6]

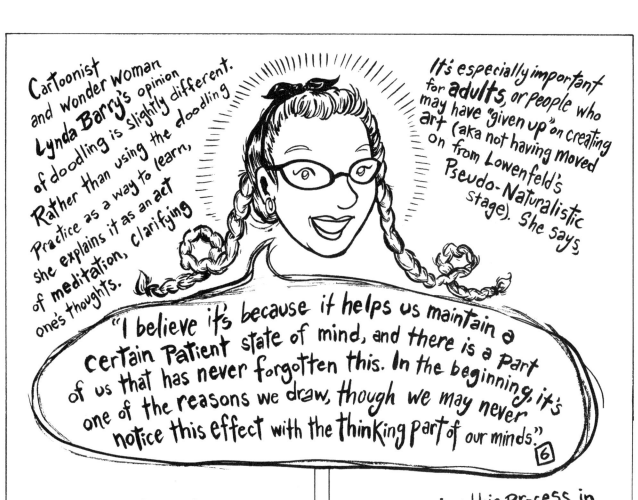

The **practice** of mark-making is **Vitally** important in any realm of visual art...

but **keeping** this process in our daily lives is the most **valuable** as we grow older.

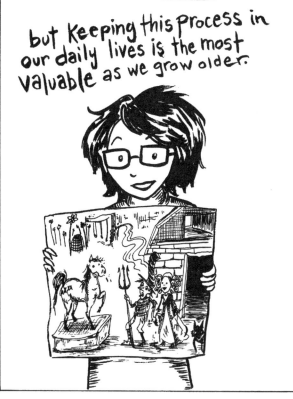

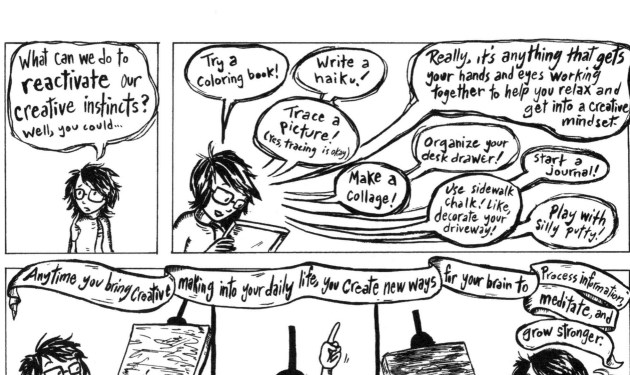

What can we do to **reactivate** our creative instincts? Well, you could...

Try a coloring book!

Write a haiku!

Trace a Picture! (yes, tracing is okay)

Make a Collage!

Organize your desk drawer!

Use sidewalk chalk! Like, decorate your driveway!

Start a journal!

Play with silly putty!

Really, it's anything that gets your hands and eyes working together to help you relax and get into a creative mindset.

Anytime you bring creative making into your daily life, you create new ways for your brain to process information, meditate, and grow stronger.

I call it "Reverse Mermaid".

I think everyone wants to be creative and to feel **freedom in play**, yet we deny ourselves the opportunity for fear of looking **foolish**. God forbid people be seen **having fun!**

We could remove this barrier by embracing imagination and creativity in modern education through art classes. Children are especially good at imagining and creating!

This is because their brains are busy processing new information through **incidental learning**; that is, learning about a concept or process primarily through observation and interaction, and without explicit instruction from others.

DUDE, give him zits.

Like this?

GIVE HIM A MUSTACHE!

HA HA!

I can't figure out how to put the mouth on this.

Here, lemme try it.

This is the BEST thing I've ever made!

So CUTE!

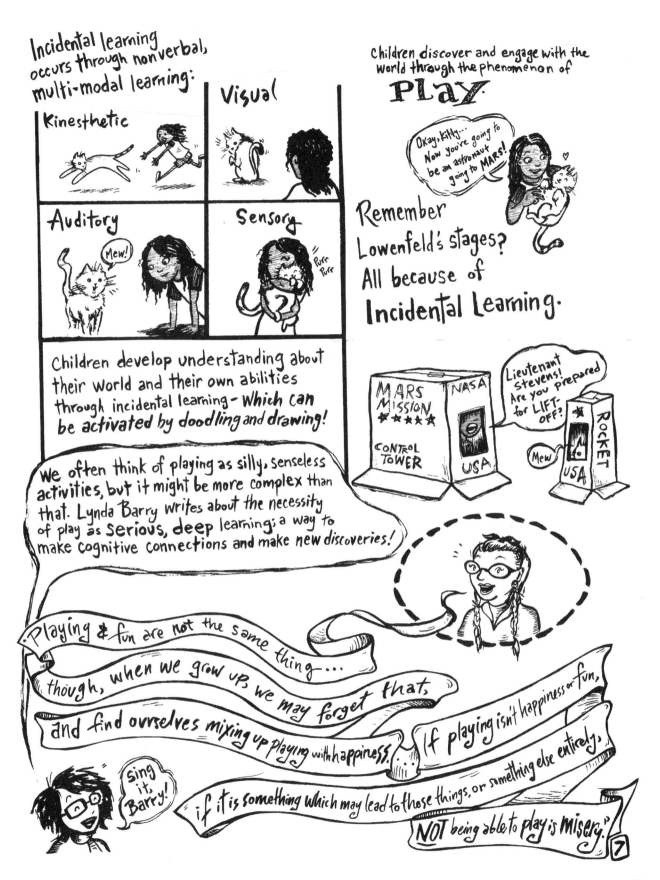

Incidental learning occurs through nonverbal, multi-modal learning:

Kinesthetic

Visual

Auditory

Mew!

Sensory

Purr Purr

Children develop understanding about their world and their own abilities through incidental learning — which can be **activated by doodling and drawing!**

We often think of playing as silly, senseless activities, but it might be more complex than that. Lynda Barry writes about the necessity of play as **serious, deep** learning; a way to make cognitive connections and make **new discoveries!**

Children discover and engage with the world through the phenomenon of

PLAY.

Okay, kitty... Now you're going to be an astronaut going to MARS!

Remember Lowenfeld's stages? All because of **Incidental Learning.**

MARS MISSION ★★★★★ CONTROL TOWER

NASA USA

Lieutenant Stevens! Are you prepared for LIFT-OFF?

Mew

ROCKET USA

"Playing & fun are not the same thing... though, when we grow up, we may forget that, and find ourselves mixing up playing with happiness. If playing isn't happiness or fun,

Sing it, Barry!

if it is something which may lead to those things, or something else entirely, NOT being able to play is misery."

⑦

Art education is fundamentally based on play, on discovery and **investigation** – and having meaningful experiences!

It is vital to the development of children, and something easily lost in a world of **right answers.**

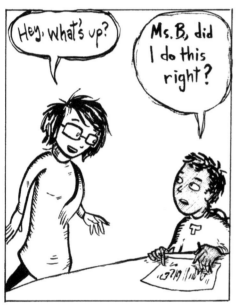

Hey, what's up?

Ms. B, did I do this right?

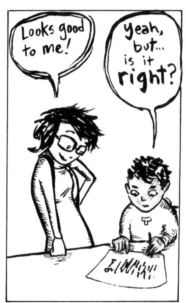

Looks good to me!

yeah, but... is it **right?**

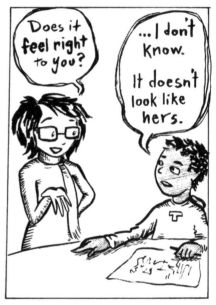

Does it feel right to you?

...I don't know. It doesn't look like hers.

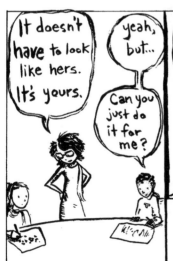

It doesn't have to look like hers. It's yours.

yeah, but...

Can you just do it for me?

NO WAY! Look, I can see that you're really thinking about this project, and working hard on it.

And that's the only right thing about this project.

sigh...

you're doing great. Really.

okay. thanks, Ms. B.

I like to think that my greatest asset as a teacher is giving children the space to reconnect with their instinctual art abilities, and to reinforce the idea that when you're creating, there are no mistakes, only opportunities.

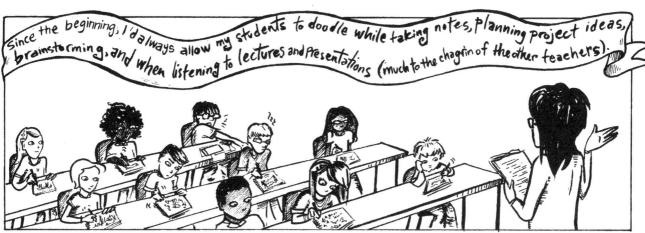

Since the beginning, I'd always allow my students to doodle while taking notes, planning project ideas, brainstorming, and when listening to lectures and presentations (much to the chagrin of the other teachers).

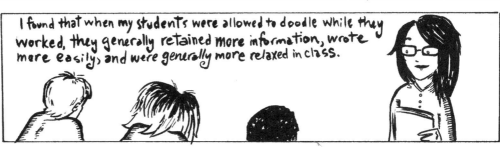

I found that when my students were allowed to doodle while they worked, they generally retained more information, wrote more easily, and were generally more relaxed in class.

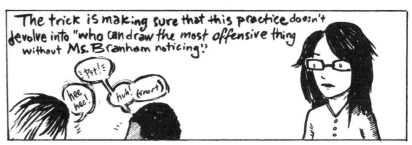

The trick is making sure that this practice doesn't devolve into "who can draw the most offensive thing without Ms. Branham noticing."

Why do they do that?

... who are these children?

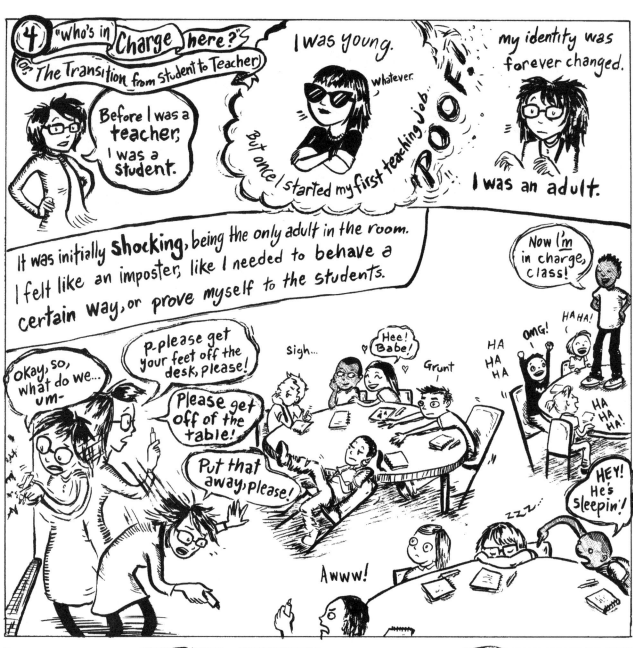

④ "who's in Charge here?"
The Transition from Student to Teacher

Before I was a teacher, I was a student.

I was young. whatever. But once I started my first teaching job "P-O-O-F!"

my identity was forever changed.

I was an adult.

It was initially **shocking,** being the only adult in the room. I felt like an imposter, like I needed to behave a certain way, or prove myself to the students.

Now I'm in charge, class!

Okay, so, what do we... um-

p-please get your feet off the desk, please!

Please get off of the table!

Put that away, please!

Sigh...

Hee! Babe!

Grunt

HA HA HA

OMG!

HA HA!

HA HA HA!

HEY! He's sleepin'!

zzz

Awww!

MS. BRANHAM!

Huh? Is my mom here?

oh, right.

Wow! what a privelge.

FACULTY ONLY!

FLUSH

Whoa! So many KEYS! The power...

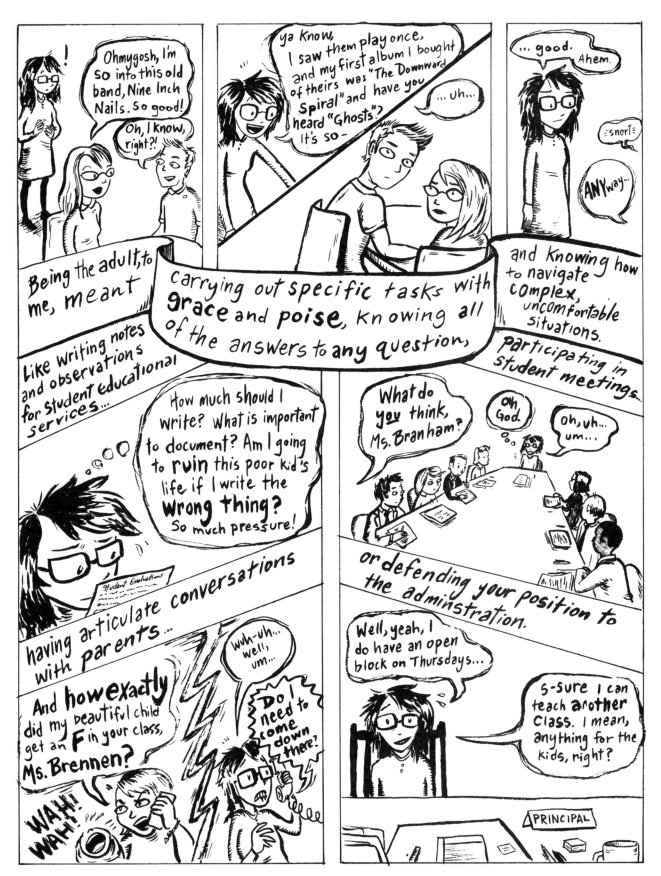

Being an adult also involves participation in possibly the **weirdest** situation of all...

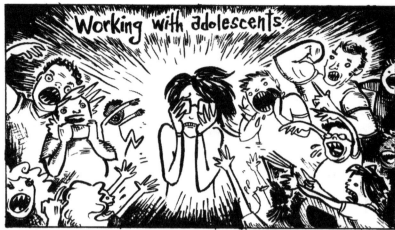

Working with adolescents.

THE AWKWARD ZONE

What to do when a student forcibly grabs your arm and licks it.

Almost anything you say can be misinterpreted and used against you.

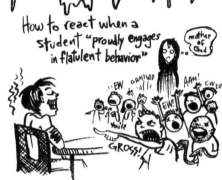

How to react when a student "proudly engages in flatulent behavior"

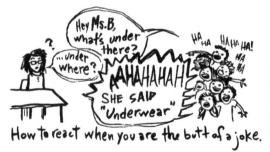

How to react when you are the butt of a joke.

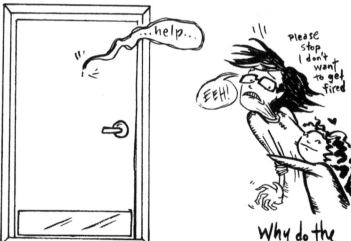

What to do when your class locks you in the supply closet.

Why do the children keep HUGGING me?

How to respond to emotionally damaged students.

One of the weirdest experiences as a teacher, as an adult, is seeing "**those kids**" that I knew when I was a student in school. It's like **pod people**... Children never really seem to change.

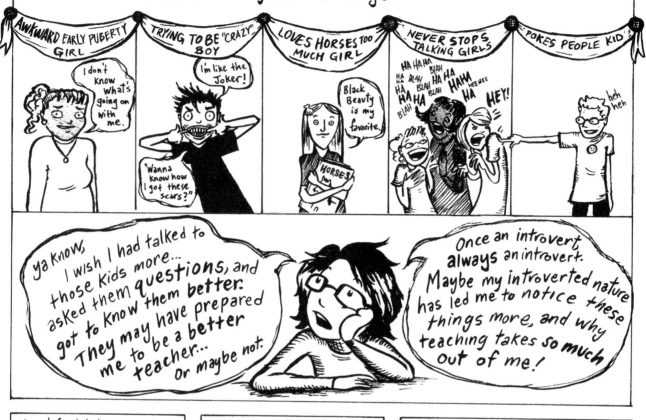

Ya know, I wish I had talked to those kids more... asked them questions, and got to know them better. They may have prepared me to be a better teacher... Or maybe not.

Once an introvert, **always** an introvert. Maybe my introverted nature has led me to notice these things more, and why teaching takes so **much** out of me!

I've definitely become more comfortable talking in front of other people,

although it's **easier** when those people are **children** rather than adults.

Teaching takes **courage**, it takes **guts**. It takes... yes! Beast mode!

a **healthy immune system**.

"Ahh..." **ACHOO!!!** Recycled germs!

Speaking of recycled air...

ever notice how schools tend to **look** and **feel** the same too– even in buildings that weren't designed to be schools?

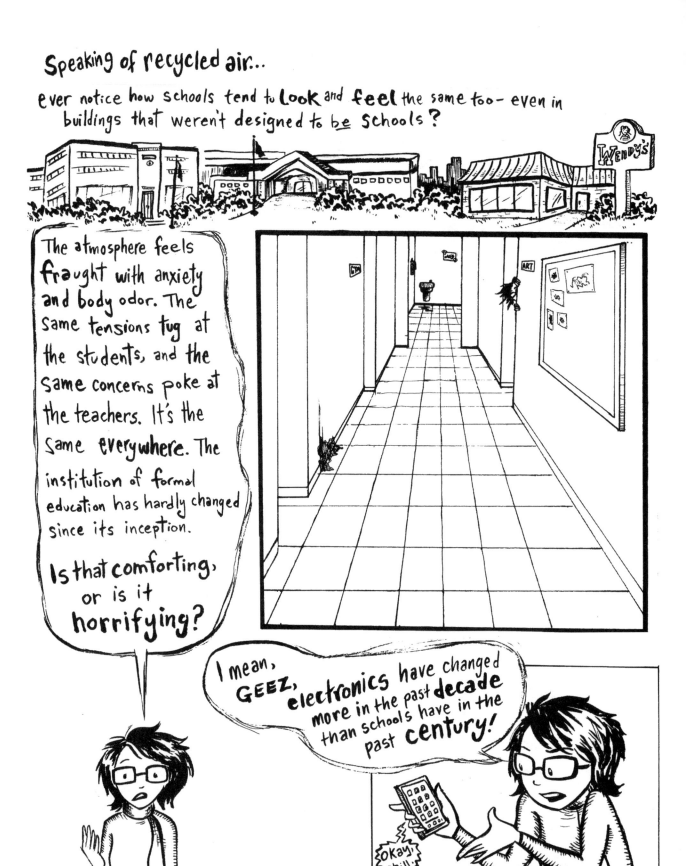

The atmosphere feels **fraught** with anxiety and body odor. The same tensions tug at the students, and the same concerns poke at the teachers. It's the same **everywhere**. The institution of formal education has hardly changed since its inception.

Is that comforting, or is it **horrifying?**

I mean, GEEZ, electronics have changed more in the past **decade** than schools have in the past **century!**

okay, chill.

The building where school happens is an important factor in a child's education.

The quality of the facilities and the overall appearance greatly impact the success of each school day.

Do these computers work?

INTERNET SAFETY

What about these toilets?

The heating?

The air conditioning?

How 'bout the ventilation?

Do the locks work?

Is there natural light?

What's the classroom layout like?

Is there enough space to move?

?.? ?

Are there enough drinking fountains?

Are there enough seats in the cafeteria?

Is there an ancient burial ground under the foundation?

? ? .?

What about what kind of school it is? Sure, there are many more **school choices** for children than there were before - but what does that **mean?**

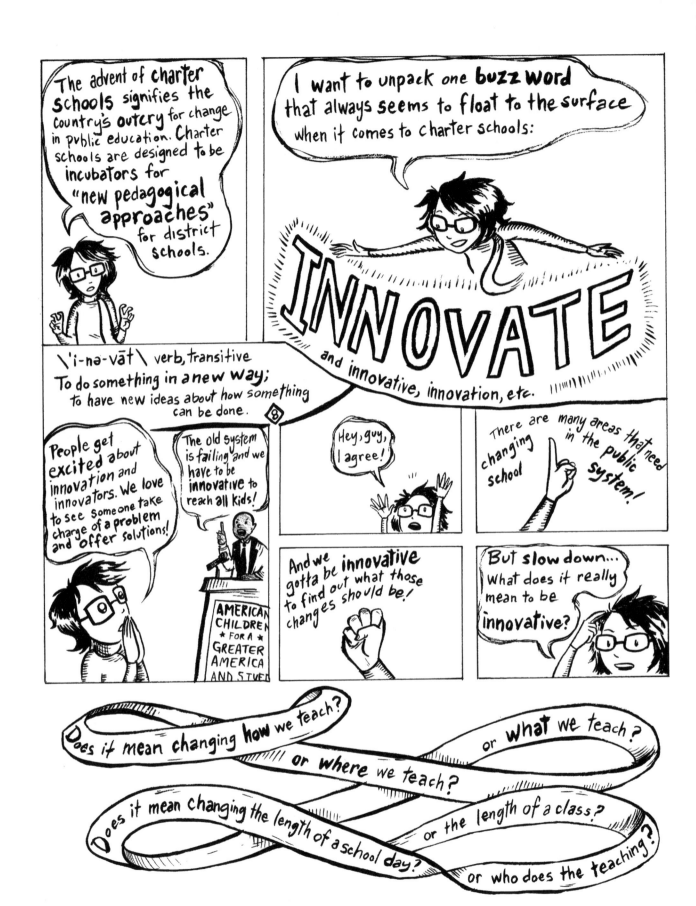

GEEZ! That's an **awful** lot of factors to consider— no wonder we still haven't figured out how to get it right!

If being innovative is so important, shouldn't **all** schools be willing to adopt practices and teaching methods to fit a wide range of learners?

Why isolate the opportunity to one individual school?

$?

The trouble with innovation is that it's hard to **quantify**. It's hard to know what **exactly** works, so it can be replicated in other settings.

What works for some may not work for all, but what works for all students should be the basis of public education, no?

$\sqrt{Rigor/taxes}$ (excellence) + funding × ? (innovation) ?

Universal Student = Sucess

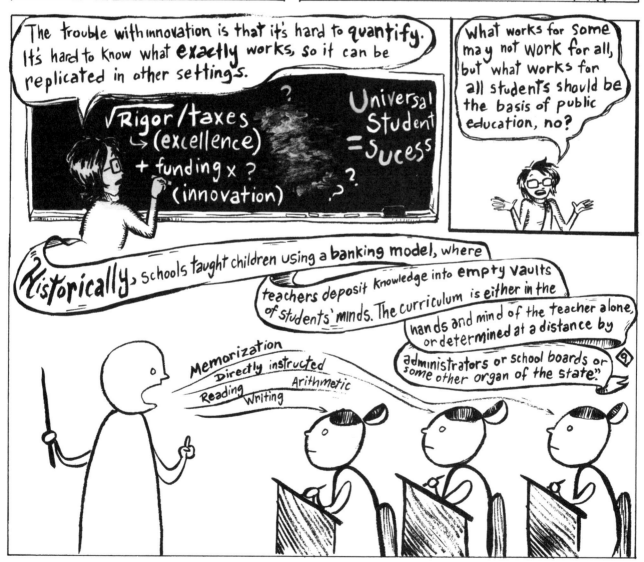

Historically, schools taught children using a **banking model**, where teachers deposit knowledge into **empty vaults** of students' minds. The curriculum is either in the hands and mind of the teacher alone, or determined at a distance by administrators or school boards or some other organ of the state."

Memorization
Directly instructed
Reading Writing Arithmetic

There have been some **pretty cool schools** that have approached education **differently...** like the

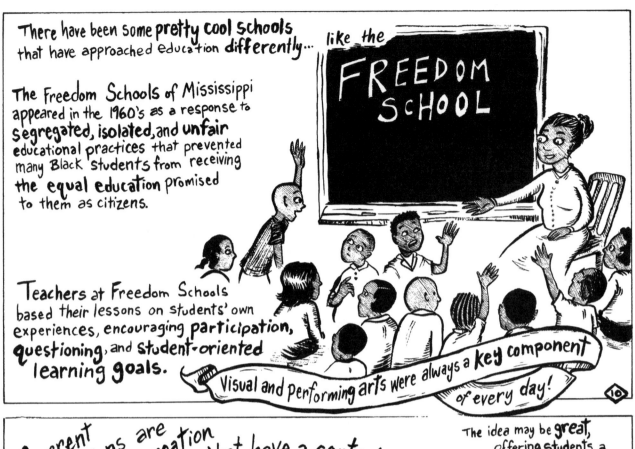

FREEDOM SCHOOL

The Freedom Schools of Mississippi appeared in the 1960's as a response to **segregated, isolated, and unfair** educational practices that prevented many Black students from receiving **the equal education** promised to them as citizens.

Teachers at Freedom Schools based their lessons on students' own experiences, encouraging **participation, questioning**, and **student-oriented learning goals.**

Visual and performing arts were always a **key component** of every day!

Current innovations are leading to the creation of schools that have a central philosophy or concept, like design, healthcare, technology, performance, etc.

The idea may be **great,** offering students a chance to develop a passion, and to use it as a tool for **learning!**

But...

These schools are usually located in cities, creating **unequal** opportunities for students who live in **suburban** or **rural areas,** unable to attend.

Even students in cities don't always have access to "innovative" schools – whether it's the luck of the lottery, transportation issues, etc. **Who gets to benefit** from **innovative education?**

Who can afford to take a chance on **innovation?**

How did we get to **this point?**

⑤ "How is art even a class?"

(or: A Short History of Art Education in America)

With so many educational options, it is important to think about how we got to this point, and where art fit into the equation.

So, where and when did art education begin, and how has it changed with public education? Well...

CRACK

Let's find out!

MAGIC TIME WARP

hee hee!

(don't abuse magic time warp powers, kids)

...which I guess looked like this →

Teaching art in formal schools (which are also a fairly new institution) began in America's earliest years, in the Massachusetts Bay colonies...

It was Benjamin Franklin who first pushed the idea of including art in the basic curriculum, as a way to help meet the practical needs of everyday life through craft.
But that was in the 1700's. The 1600's came first...

And in the colonial days, the arts were Utilitarian - they served a purpose.

HOME SWEET HOME

And that purpose was to help aid in the teaching of the scriptures to hedonistic young people.

And the "Old Deluder Satan" Act was passed to do just that.

Oh, Puritans!

Surely the Puritans could not afford the time or moral energy to combat the immoral forces of fine art. They were a practical people.

Formal arts education was reserved for only the **wealthiest** children.

Goodetown
est. 1680
NO SINNERS

some time passes, then...

In the 1800's, everything got all fancy.

The Industrial Age had begun, and American societies were thriving. Coal smoke and decorative embellishment covered everything.

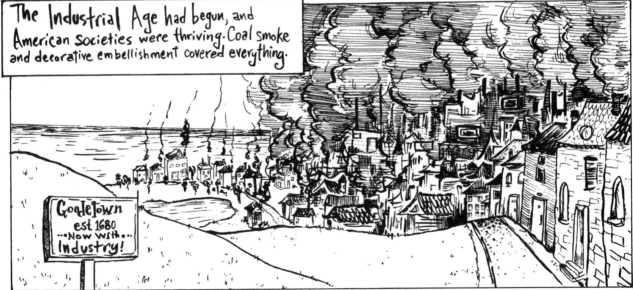

Goodetown
est 1680
...Now with...
Industry!

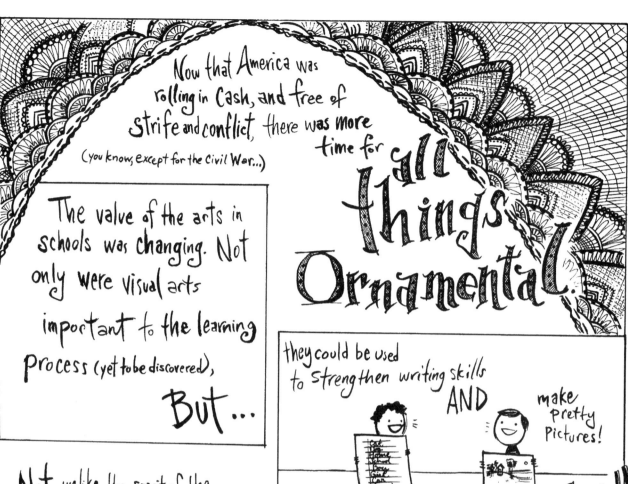

Now that America was rolling in Cash, and free of strife and conflict, there was more time for all things Ornamental.

(you know, except for the Civil War...)

The value of the arts in schools was changing. Not only were visual arts important to the learning process (yet to be discovered), But...

they could be used to strengthen writing skills AND make pretty pictures!

Wow!

Not unlike the spirit of the Industrial Revolution, the practice of drawing also became more valuable in the developing world of trade and commerce, particularly in machine design and architecture.

It seemed that finally art had become less about **human instinct**, and more about **Capitalism.**

Pout

Anyway.

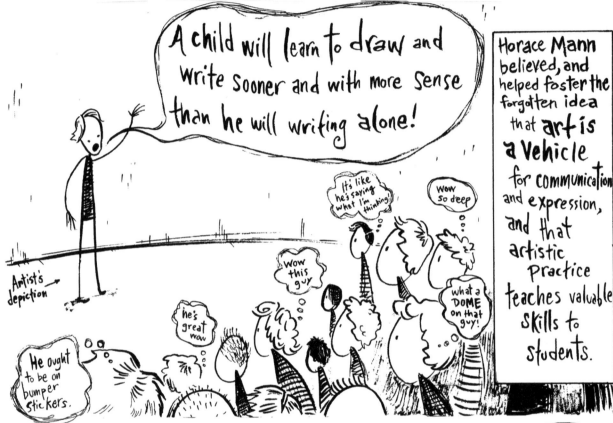

A child will learn to draw and write sooner and with more sense than he will writing alone!

Artist's depiction

He ought to be on bumper stickers.

he's great wow

Wow this guy

It's like he's saying what I'm thinking!

Wow so deep

what a DOME on that guy!

Horace Mann believed, and helped foster the forgotten idea that **art is a vehicle** for communication and expression, and that artistic practice teaches valuable skills to students.

Mann made it a point to say that art helped "rescue children from the disgust of school," which may explain the attitudes toward art education **today.**
(Still might be true, though.)

EWW SCHOOL.

BARF.

YAY ART!!

WOO HOO! AWESOME!

Peter Schmidt

Horace Mann

So, being the education maverick he was, Horace Mann hired a drawing instructor from Prussia, Peter Schmidt, to create some drawing lessons to be printed in his magazine, Common Schools Journal.

American art educator Walter Smith also jumped on the bandwagon, and developed a whole book of drawing lessons, premade for convenient use!

DRAWING BOOK

OF STANDARD REPRODUCTIONS AND ORIGINAL DESIGNS

FOR

PUBLIC SCHOOLS, DRAWING CLASSES, AND SCHOOLS OF ART IN AMERICA

Edited and Designed

BY

WALTER SMITH

STATE DIRECTOR OF ART EDUCATION, MASSACHUSETTS

Walter Smith

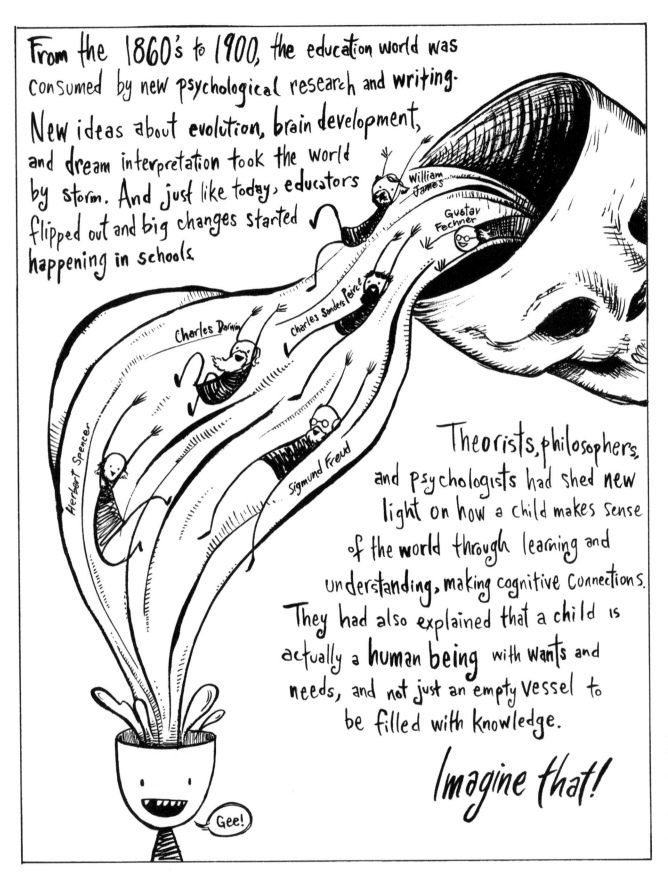

From the 1860's to 1900, the education world was consumed by new psychological research and writing.

New ideas about evolution, brain development, and dream interpretation took the world by storm. And just like today, educators flipped out and big changes started happening in schools.

William James

Gustav Fechner

Charles Sanders Peirce

Charles Darwin

Herbert Spencer

Sigmund Freud

Theorists, philosophers, and psychologists had shed new light on how a child makes sense of the world through learning and understanding, making cognitive connections. They had also explained that a child is actually a human being with wants and needs, and not just an empty vessel to be filled with knowledge.

Imagine that!

Gee!

In the early 1900's, John Dewey's progressive education theories held public school **art** in higher regard than **ever before!** Art provided children with opportunities for self-expression, which helped them develop **character.**

This era marked the inception of arts-integration and **project-based learning** in school too, as children were encouraged to pursue their own interests through creative means.

POP

By creating practical projects in conjunction with academic studies, arts integration also served to help with concept formation as children learned.

SOLAR SYSTEM

VOLCANO

SCI FA

WARHEAD

Dewey made sure that educators knew "art [was] everywhere, in every experience, and that each moment should be appreciated aesthetically."

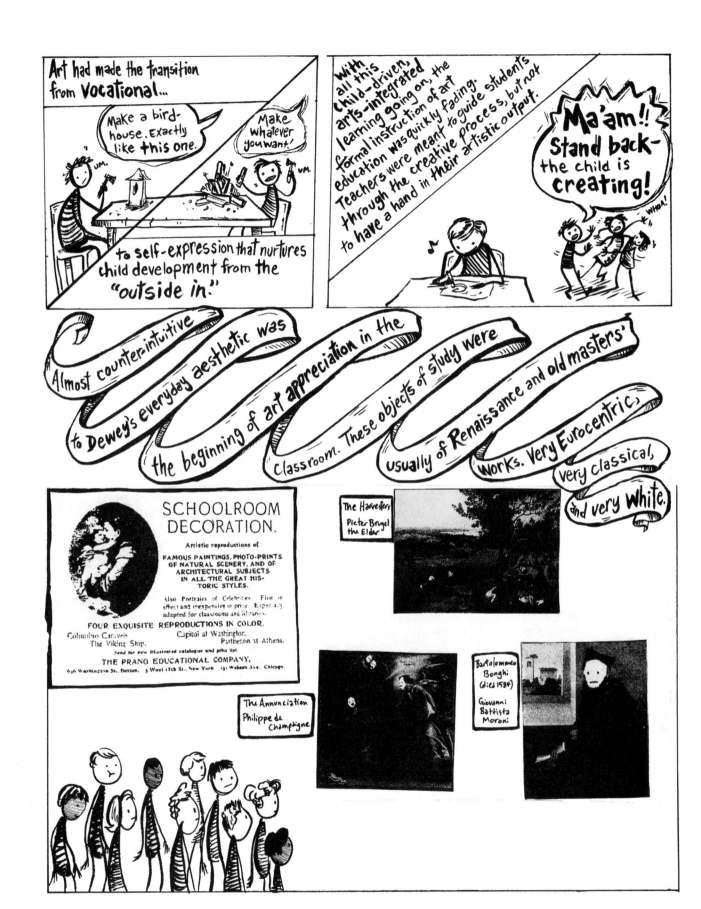

Art had made the transition from **vocational**...

Make a bird-house. Exactly like this one.

um.

Make whatever you want!

um.

to self-expression that nurtures child development from the "outside in."

With all this child-driven, arts-integrated learning going on, the formal instruction of art education was quickly fading. Teachers were meant to guide students through the creative process, but not to have a hand in their artistic output.

Ma'am!! Stand back— the child is **creating!**

WHOA!

Almost counter-intuitive to Dewey's everyday aesthetic was the beginning of art appreciation in the classroom. These objects of study were usually of Renaissance and old masters' works. Very Eurocentric, very classical, and very **white**.

The Harvesters
Pieter Bruegel the Elder

The Annunciation
Philippe de Champaigne

Bartolommeo Bonghi
(died 1584)

Giovanni Battista Moroni

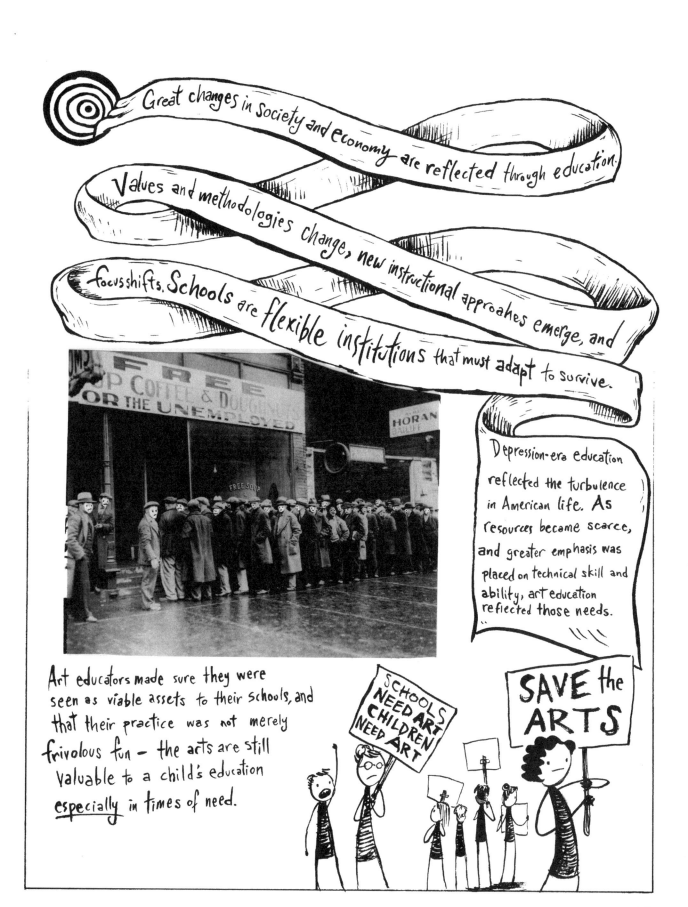

Great changes in society and economy are reflected through education.

Values and methodologies change, new instructional approaches emerge, and focus shifts. Schools are flexible institutions that must adapt to survive.

Depression-era education reflected the turbulence in American life. As resources became scarce, and greater emphasis was placed on technical skill and ability, art education reflected those needs.

Art educators made sure they were seen as viable assets to their schools, and that their practice was not merely frivolous fun — the arts are still valuable to a child's education especially in times of need.

SCHOOLS NEED ART CHILDREN NEED ART

SAVE the ARTS

Students returned to woodshops

Hmm.

and sewing machines...

Hmm.

Learning interior decorating, material manipulation, and other utilitarian tasks.

When World War II began, art class shifted to making patriotic crafts and propaganda posters to "support the war effort."

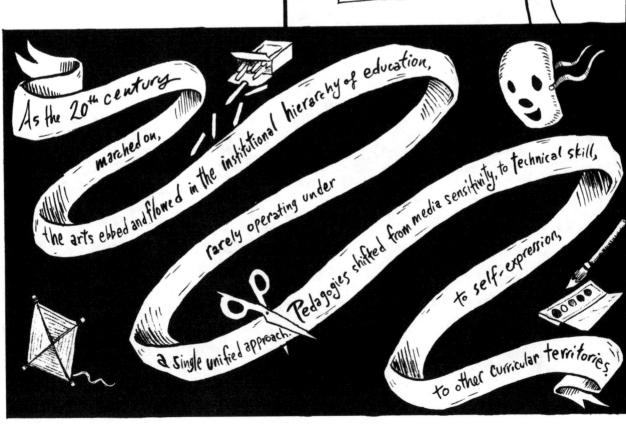

As the 20th century marched on, the arts ebbed and flowed in the institutional hierarchy of education, rarely operating under a single unified approach. Pedagogies shifted from media sensitivity, to technical skill, to self-expression, to other curricular territories.

Yet, one factor in the history of art education is the tenacity of its teachers and advocates, continuously reinventing their pedagogy, practice, and principles to fit the needs of individual schools and communities. These educators are steadfast regardless of whether art education is at the forefront of the education agenda, or in the background.

Recently, the latter has been the norm.

The Reagan Administration handled many crises in America, for better or worse, including the Cold War, the AIDS pandemic, the Nuclear Arms Race, and the War on Drugs.

In the 1980's, it seemed on the surface that America's child-centered education system was failing and the United States was losing the competitive edge it once held after the Space Race years, as student scores in science and math **stagnated.**

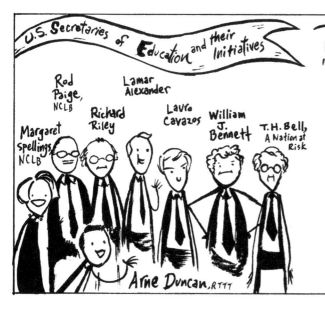

U.S. Secretaries of Education and their Initiatives

Margaret Spellings, NCLB
Rod Paige, NCLB
Richard Riley
Lamar Alexander
Lauro Cavazos
William J. Bennett
T.H. Bell, A Nation at Risk
Arne Duncan, RTTT

The administration's cautionary memo, "A Nation at Risk" outlined new measures for national education that downplayed creative and critical thinking and artmaking, and emphasized a "back to basics" (that's readin', writin', & 'rithmetic) curriculum that would eventually spur the era of standardized testing and high-stakes external accountability.

Following "A Nation at Risk" were the "**No Child Left Behind**" (NCLB) documents of the Bush Jr. administration,

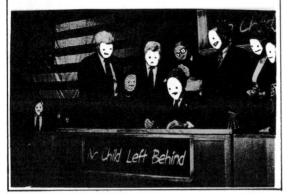

and the "**Race to the Top**" (RTTT) orders from the Obama administration.

Following both of these is the **Every Child Achieves Act.**

This bill gives states more decision-making power over how schools and teachers are evaluated, how money is spent, how testing data is used, and generally offers more support for the most vulnerable students.

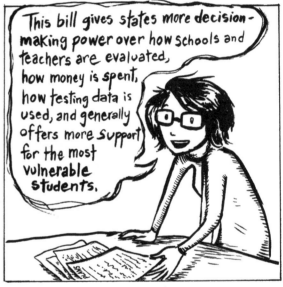

To me, this bill gives me hope that schools will be less focused on **test results** in academic subjects, and more ready to **strengthen** arts programs and other opportunities for **well-rounded holistic** education.

Will this put art education back into the **forefront** of American Public schools? Only **time** will tell!

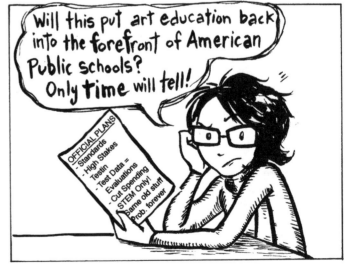

OFFICIAL PLANS!
- Standards
- High Stakes Testin'
- Test Data = Evaluations
- Cut Spending
- STEM Only!
Same old stuff Prob. forever

6 "UGH"... *(or, Why We Care About Standards and Assessment)*

You might be a little confused about all the **fuss** regarding testing and standards, and all that stuff.

I know I usually am!

What are "standards," anyway?

Standards are, essentially, the things a student should be able to know or do by a specific grade level.

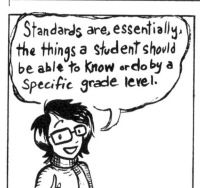

Nice, quantifiable subjects...

ART

with *nice, quantifiable* measures.

standard 1 | standard 2 | 3 | 4 | 5 | standard 6

The issue with standards is that some people say they are too rigid and

CO NF IN IN G!!!

and that they **force teachers** to teach a certain way. While it's true that standards define explicit things to teach,

1.10 1.10

I think of them as **jumping-off points** for curriculum design.

1.10 → Project

Here's an example that I use:

Massachusetts state standard for the Arts, Pre K-12, Standard 1 (Methods, Materials, and Techniques), Standard 1.10.

"By the end of basic study in grades 9-12, students will use electronic technology for reference and for creating original work."

⑬

9th grade
I used the internet to find reference photos of wolves for a papier mâché project.

10th grade
I researched 18th century landscape painters-I never knew about them!

11th grade
I used Photoshop to manipulate photos and made surrealist images!

12th grade
I created a digital portfolio of all my best artwork-and got accepted to an art program!

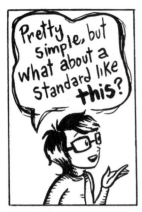

Pretty simple, but what about a standard like **this?**

Massachusetts State standard for the Arts, PreK-12, Standard 6 (Purposes and Meaning in the Arts), Standard 6.7. "Compare examples of works in one arts domain (dance, music, theatre, visual arts, or architecture) from several periods or cultures and explain the extent to which each reflects function, customs, religious beliefs, social philosophies, aesthetic theories, economic conditions, and/or historical or political events." ⑭

yeeaaah... that's a little more **complicated** huh?

Let's see what we can do with this.

—CRACK—

I know I want to teach, say, **printmaking** to my class.

I can include a lesson describing different printing methods and styles from across continents and time periods, notice similarities and **differences**, and engage in a group critique on a few works.

The conversation alone can open up many avenues for students to build connections to concepts learned in their academics courses, like **social studies, economics, English, civics,** and many others!

I think many teachers have difficulty teaching children effectively when confronted with CCSS anchor standards (more on that later).

Take this one for instance:

CCSS.ELA-LITERACY.CCRA.L.4.
"Determine or clarify the meaning of unknown and multiple-meaning words and phrases by using context clues, analyzing meaningful word parts, and consulting general and specialized reference materials as appropriate." ⑮

What the **heck** is that about?!

It's densely packed, and a little intimidating.

The **stress** of applying standards is definitely in the **wording**, and in the **naming** of valuable teaching techniques that are already being used.

But, you know...

I believe a lot of classroom teachers already do things like these...

through class discussions, show-and-tell, circle time, etc...

Don't get too **worked up** about it.

Okay, now, what are "assessments"

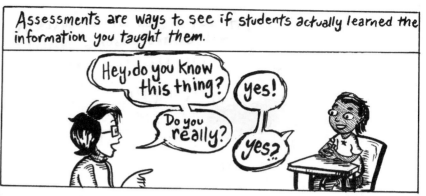

Assessments are ways to see if students actually learned the information you taught them.

Hey, do you know this thing?

Do you really?

Yes!

Yes?

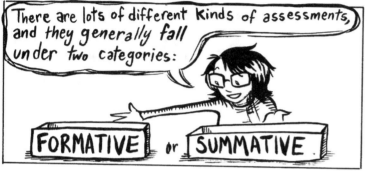

There are lots of different Kinds of assessments, and they generally fall under two categories:

FORMATIVE or SUMMATIVE

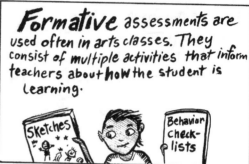

Formative assessments are used often in arts classes. They consist of multiple activities that inform teachers about **how** the student is learning.

Sketches

Behavior Check-lists

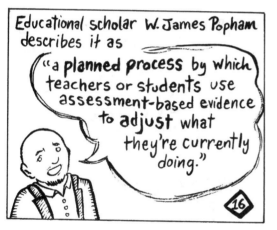

Educational scholar W. James Popham describes it as

"a **planned process** by which teachers or students use assessment-based evidence to **adjust** what they're currently doing."

16

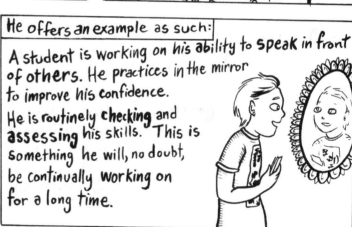

He offers an example as such:

A student is working on his ability to **speak in front of others.** He practices in the mirror to improve his confidence.

He is routinely **checking** and **assessing** his skills. This is something he will, no doubt, be continually working on for a long time.

Summative assessments are used less frequently. They are administered as **a means to an end**, to get a final and concrete image of what a student knows at the end of a lesson, unit, or grade. They are **finite,** so they cannot effectively guide instruction.

THE BIG TEST

The assessments that seem to matter **the most** in today's educational climate are summative assessments known as **standardized tests.**

Wait, what's a standardized test?

A Perfect Union of EVIL FORCES!

No, not really... well, maybe.

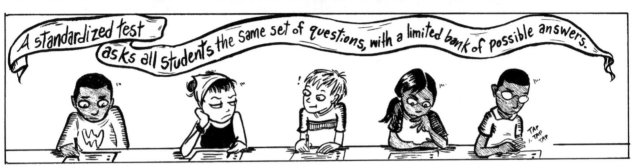

A standardized test asks all students the same set of questions, with a limited bank of possible answers.

The test aligns directly to the standards taught to students in a specific grade.

4.CS.4 Major rights immigrants receive as citizens

⬇

1. A right an immigrant gains upon becoming a U.S. citizen

A) Travel C) Vote
B) No Taxes D) Be president

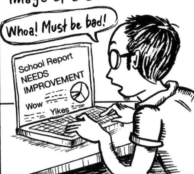

The results from standardized tests directly impacts the image of a school...

Whoa! Must be bad!

School Report
NEEDS
IMPROVEMENT
Wow Yikes

and the image of students.

Whoa... I must be dumb...

Test Results
REALLY
NEEDS
IMPROVEMENT

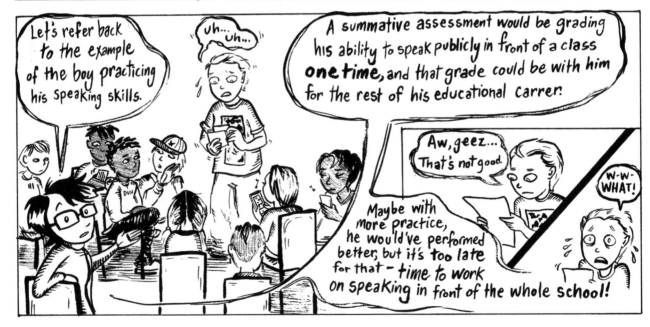

Let's refer back to the example of the boy practicing his speaking skills.

uh.... uh...

A summative assessment would be grading his ability to speak publicly in front of a class **one time**, and that grade could be with him for the rest of his educational carrer.

DUH

Aw, geez... That's not good.

Maybe with more practice, he would've performed better, but it's **too late** for that - time to work on speaking in front of the whole school!

W-W-WHAT!

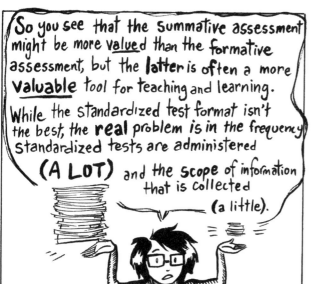
So you see that the summative assessment might be more va<u>lue</u>d than the formative assessment, but the **latter** is often a more **valuable** tool for teaching and learning.

While the standardized test format isn't the best, the **real** problem is in the frequency standardized tests are administered **(A LOT)** and the **scope** of information that is collected (a little).

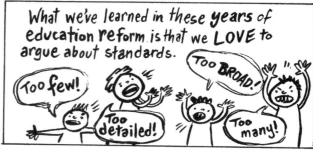
What we've learned in these **years** of education **re**form is that we **LOVE** to argue about standards.

Too few!

Too detailed!

Too BROAD!

Too many!

So let's look at a recent revision of the national curriculum—the **Common Core State Standards** initiative.

CCSS emphasizes the importance of "College and Career Readiness" by high school graduation.

This is a hot topic, because many young people have insisted that their public school education did not adequately prepare them for, well, **College** or a **career**.

Yeah, I have an exam tomorrow, but I'd MUCH rather go out!

SNAPCHAT! EMOJIS!

Right? Like, what is time management?? LOL

Because this is a new **century**, with new **challenges** and **expectations**, new sets of skills—"21st century skills"—have to be included in a state's curriculum (if the state agrees to adopt **CCSS**, of course).

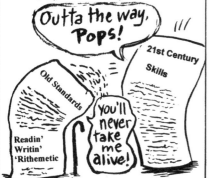
Outta the way, **Pops!**

Old Standards

21st Century Skills

Readin' Writin' 'Rithemetic

You'll never take me alive!

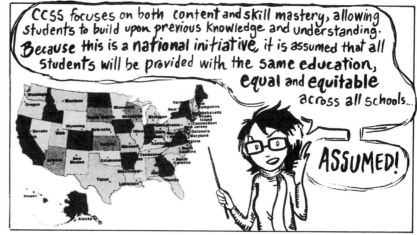
CCSS focuses on both content and skill mastery, allowing students to build upon previous knowledge and understanding. **Because** this is a **national initiative**, it is assumed that all students will be provided with the same education, **equal** and **equitable** across all schools...

ASSUMED!

Unfortunately, standards alone cannot **change** the **status quo** of **unequal** and insufficient public education as we know it.

WHY?

Education strategies for change that **isolate, demotivate,** and **immobilize** the masses cannot make positive systemic change.

Professor Michael Fullan writes about this in his **2011 paper, "The Wrong Drivers."** He discusses four components that may help create systemic change, even though <u>they cannot stand on their own</u> as change-makers.

18

Sorry to break it to ya.

ACCOUNTABILITY

(using test results and teacher appraisal to reward and punish teachers and schools, rather than **capacity-building**)

INDIVIDUAL TEACHER AND LEADERSHIP QUALITY

(promoting individual solutions, rather than **group solutions**)

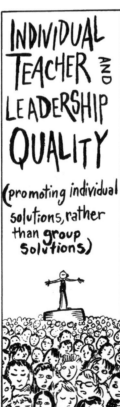

TECHNOLOGY

(investing in and assuming that the wonders of the digital world will carry the day, rather than **guided instruction**)

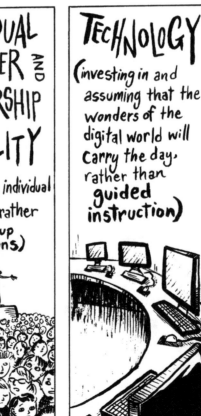

FRAGMENTED STRATEGIES

(limited, aimless, short-lived strategies, instead of **systemic long-term objectives and strategies**)

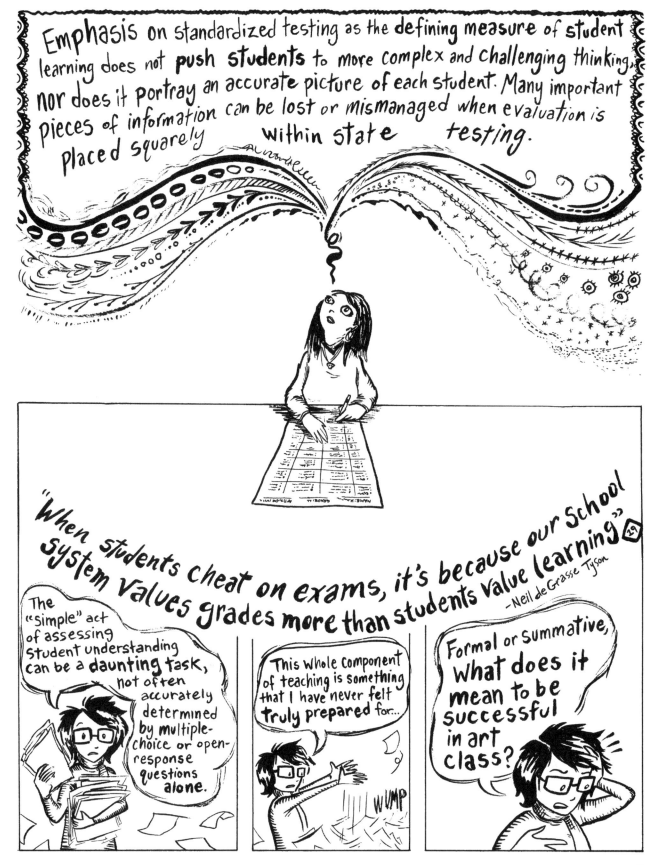

Emphasis on standardized testing as the **defining measure of student** learning does **not push students** to more complex and challenging thinking, nor does it portray an accurate picture of each student. Many important pieces of information can be lost or mismanaged when evaluation is placed squarely within state testing.

"When students cheat on exams, it's because our School system values grades more than students value learning" [39]

—Neil deGrasse Tyson

The "simple" act of assessing student understanding can be a **daunting task,** not often accurately determined by multiple-choice or open-response questions **alone.**

This whole component of teaching is something that I have never felt **truly prepared** for...

WUMP

Formal or Summative, **what does it mean to be successful in art class?**

Instead, I look for the **other** qualities of human behavior that emerge from art class.

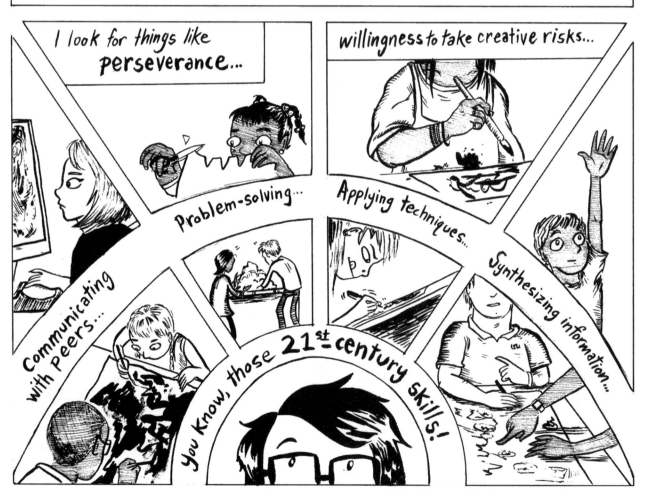

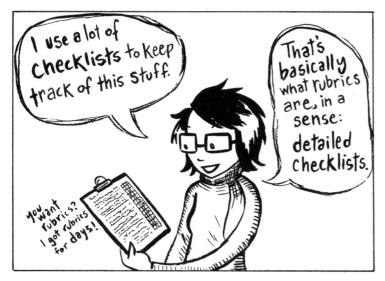

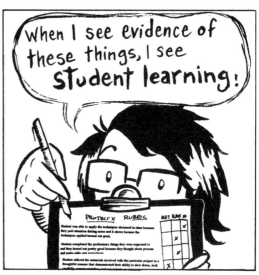

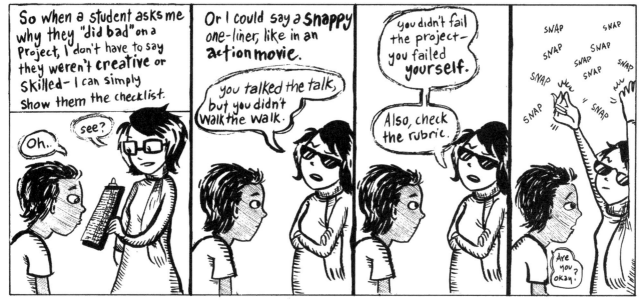

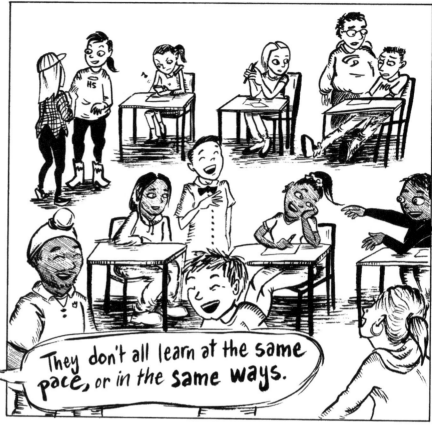

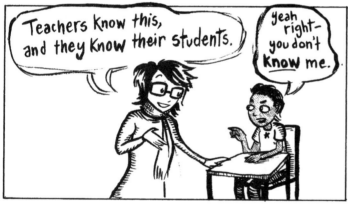

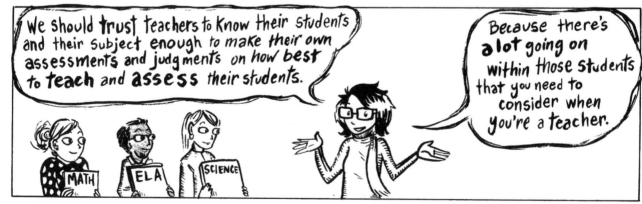

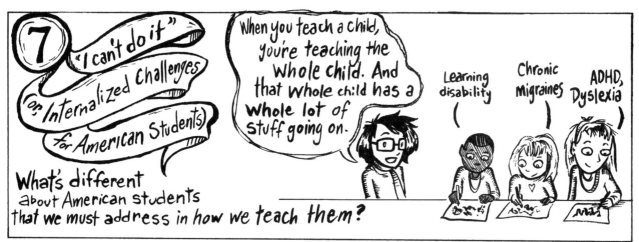

7 "I can't do it" or, Internalized Challenges for American Students)

What's different about American students that we must address in how we teach them?

When you teach a child, you're teaching the whole child. And that whole child has a whole lot of stuff going on.

Learning disability

Chronic migraines

ADHD, Dyslexia

You might not always know about the stuff going on, but you gotta adjust what you do to help that whole child to learn!

Even though the United States doesn't consider education to be a constitutional right...

Yeah! I know, right?!

I was surprised too! And enraged!

As a modern society, we must be certain that every child has access to a free education where it is offered (thankfully in every U.S. state).

But like I said before, this idea (and the deeply unsettling thought of education not being a protected constitutional right, what???) is really daunting.

Kids in modern America face unique obstacles, making the opportunity to engage with art all the more valuable during their school days!

Something especially pertinent in many classrooms are Individualized Education Plans, or IEP's, and individual accommodation plans known as **504's.** These are specialized documents developed to make sure students receive services and supports that may be needed to help them learn.

Jimmy's Individualized Education Plan (active)

Yeah, that's mine.

It's classified.

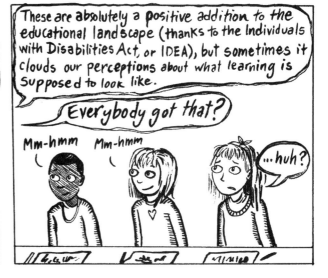

These are absolutely a positive addition to the educational landscape (thanks to the Individuals with Disabilities Act, or IDEA), but sometimes it clouds our perceptions about what learning is supposed to look like.

Everybody got that?

Mm-hmm Mm-hmm ...huh?

After all, if this child learns **one way**, and another child learns **another** way, how can you **teach** them the **same way**? And how can you **assess** them the **same way**?

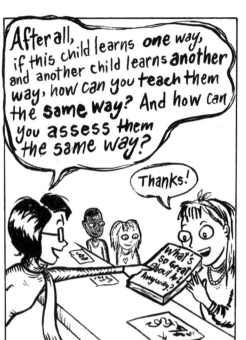

Thanks!

What's So Great About It, Anyway?

Before a class begins, I always check to see if any students have these educational documents...

2... 3... 7...

And I look the documents over to make sure I know what I should be amending, changing, or reducing in my curriculum.

This is about providing individualized instruction, but it shouldn't be restricted just to students with IEP's and 504's. Every child deserves an individualized education!

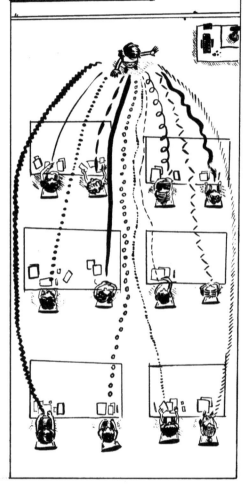

I want to take some time to look at a few of these more common terms in IEP's and 504's, because they impact my teaching and student learning most often.

Offical ed. doc.

Okay, stop me if you've heard this one before: "Attention Deficit Hyperactivty Disorder."

The term was first coined in 1994, and the number of children receiving this diagnosis has been increasing every year.

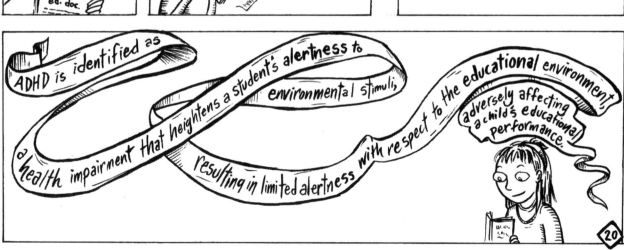

ADHD is identified as a health impairment that heightens a student's alertness to environmental stimuli, resulting in limited alertness with respect to the educational environment, adversely affecting a child's educational performance.

20

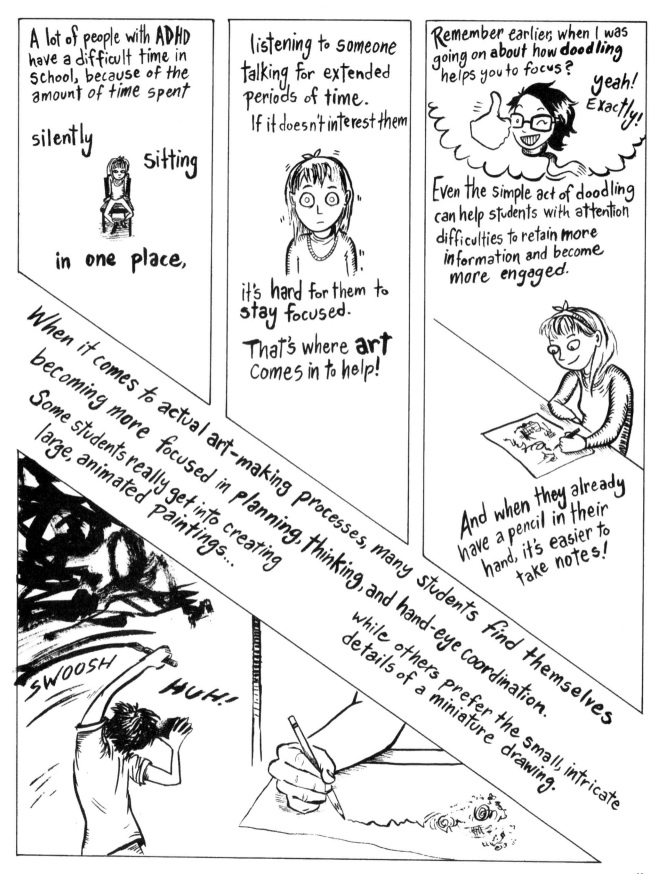

A lot of people with ADHD have a difficult time in school, because of the amount of time spent

silently sitting in one place,

listening to someone talking for extended periods of time.

If it doesn't interest them

it's hard for them to stay focused.

That's where art comes in to help!

Remember earlier, when I was going on about how doodling helps you to focus?

yeah! Exactly!

Even the simple act of doodling can help students with attention difficulties to retain more information and become more engaged.

And when they already have a pencil in their hand, it's easier to take notes!

When it comes to actual art-making processes, many students find themselves becoming more focused in planning, thinking, and hand-eye coordination. Some students really get into creating large, animated paintings... while others prefer the small, intricate details of a miniature drawing.

SWOOSH

HUH!

There is also a certain **tactile element** in art that really captivates an **active mind** and **restless hands**

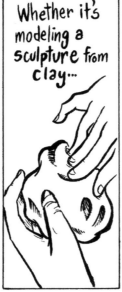
Whether it's modeling a sculpture from clay...

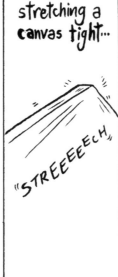
stretching a canvas tight...

"STREEEEECH"

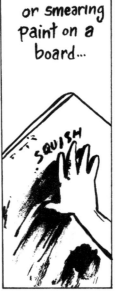
or smearing paint on a board...

SQUISH

the arts have a sort of **healing power** that can truly **transform!**

AAH...

I see ADHD and **ANXIETY** coming up all the time in my student's records.

More diagnoses from doctors, parents, even students themselves.

Are you stressed?

she's SO stressed!

Way too stressed!

This can create a passivity in many students that leads to difficulties, **both in school and later in life.**

Sorry I'm late again... I just got really anxious so I had to stay in the bathroom with my friends.

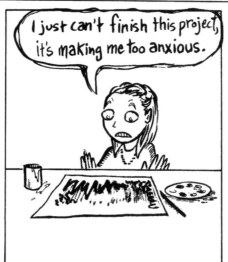
I just can't finish this project, it's making me too anxious.

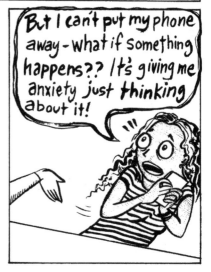
But I can't put my phone away - what if something happens?? It's giving me anxiety just thinking about it!

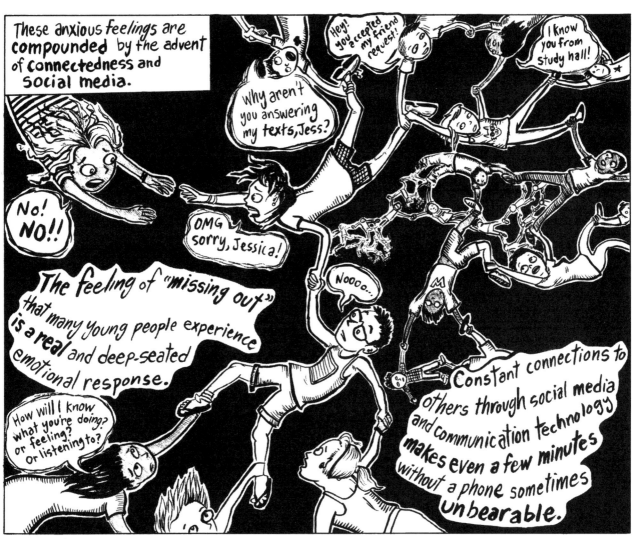

These anxious feelings are **compounded** by the advent of **connectedness** and **social media.**

Why aren't you answering my texts, Jess?

Hey! you accepted my friend request!

I know you from study hall!

No! NO!!

OMG sorry, Jessica!

Noooo...

The feeling of "missing out" that many young people experience is a **real** and deep-seated emotional response.

How will I know what you're doing? or feeling? or listening to?

Constant connections to others through social media and communication technology makes even a few **minutes** without a phone sometimes **unbearable.**

I AM UTTERLY ALONE.

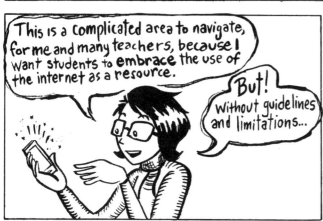

This is a complicated area to navigate, for me and many teachers, because I want students to **embrace** the use of the internet as a resource.

But! Without guidelines and limitations...

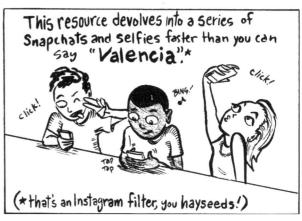

This resource devolves into a series of Snapchats and selfies faster than you can say "*Valencia*."*

click!

BANG!

TAP TAP

click!

(*that's an Instagram filter, you hayseeds!)

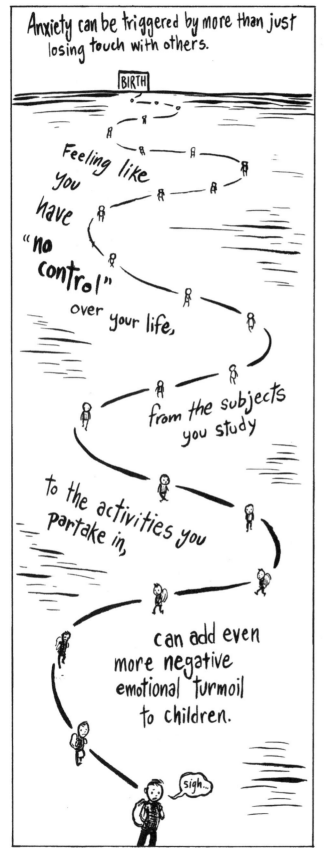

Anxiety can be triggered by more than just losing touch with others.

BIRTH

Feeling like you have "no control" over your life,

from the subjects you study

to the activities you partake in,

can add even more negative emotional turmoil to children.

sigh...

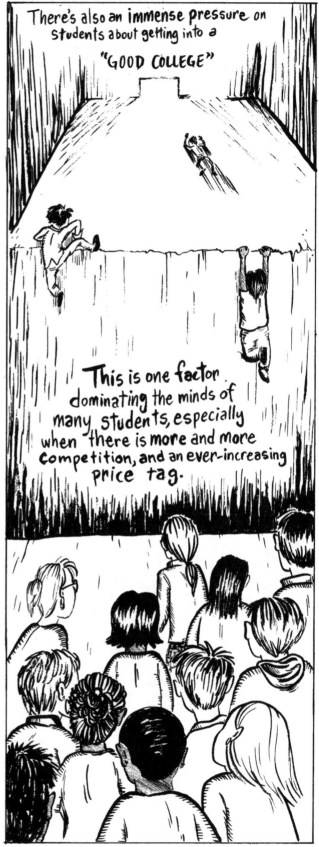

There's also an immense pressure on students about getting into a

"GOOD COLLEGE"

This is one factor dominating the minds of many students, especially when there is more and more competition, and an ever-increasing price tag.

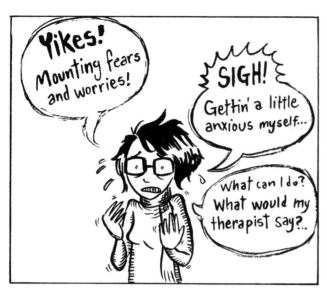

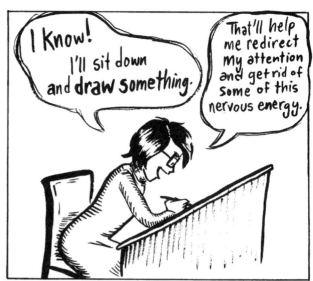

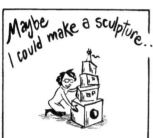

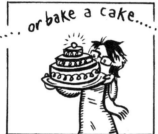

You know, I see a lot of students that have **learning disabilities**, as well.

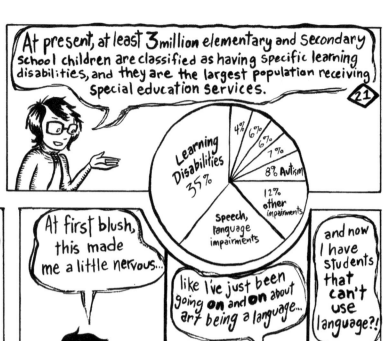

At present, at least **3** million elementary and secondary school children are classified as having specific learning disabilities, and they are the largest population receiving special education services. ㉑

Learning Disabilities 35%

4%
6%
6%
7%
8% Autism
12% other impairments
Speech, language impairments

Learning disabilities impact how someone processes or uses language, either spoken or written.

LD's

At first blush, this made me a little nervous...

like I've just been going **on** and **on** about art being a language...

LD's

and now I have students that can't use language?!

Whew! But listen— it's actually not like that at all!

LD's

This is where art becomes something **really** special.

Not only is it therapeutic and **relaxing**, but it's very different from **other** subjects that may challenge students with learning **disabilities**.

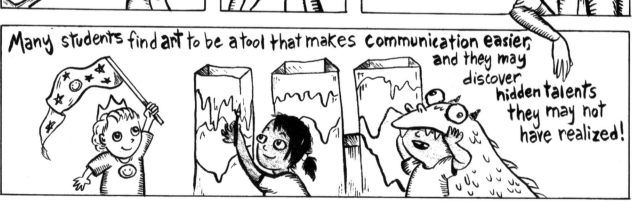

Many students find **art** to be a tool that makes **communication easier**, and they may discover **hidden talents** **they may not** **have realized!**

I had a student once who was very shy about speaking to others, due to language processing difficulties.
But her artwork was some of the most expressive and *thoughtful I'd seen!*

Another student had a lot of trouble staying focused, and he would always tell me how "bad" he was at art.

But I don't think I've ever seen a child work as hard as he did.

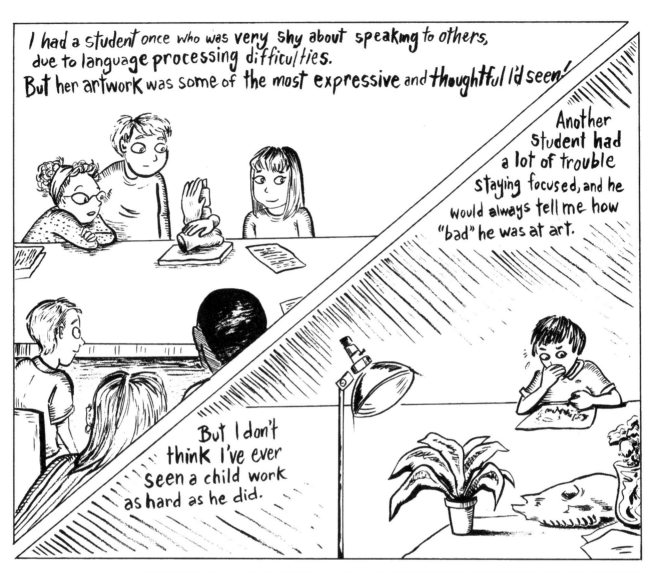

Still another student of mine had a terrible time getting started on the creative process.

With some typed guidelines, a check-list, and a little motivational coaching, she took off without hesitation.

These kinds of disabilities may be **mild** or **severe**, **obvious** or **subtle**... but should we even **call them "disabilities"?**

Are they learning **differences?** Or **preferences?**

One of my best experiences as a teacher has been working with students who **struggle** with **spatial** relationships, which are essential in visual art. These students work so hard to draw a **line**, or a **circle**, always trying to get it just right.

They challenge me to explain concepts in new ways.

Okay, let's see that—

and to keep my **filthy** hands off of their artwork.

Oop! Nope!

They challenge both my patience, and my ability to deliver the individualized instruction they deserve. Whether or not these students want to continue art as a **career**, or even a hobby, is not the goal.

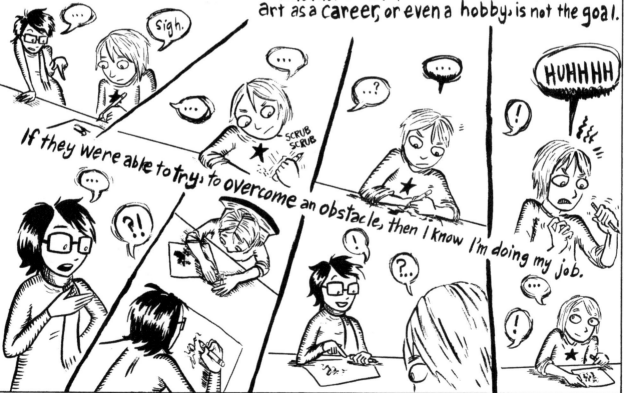

Sigh.

SCRUB SCRUB

HUHHHH

If they were able to **try**, to **overcome** an obstacle, then I know I'm doing my job.

Let's talk about another "invisible" disability in the art room—autism.

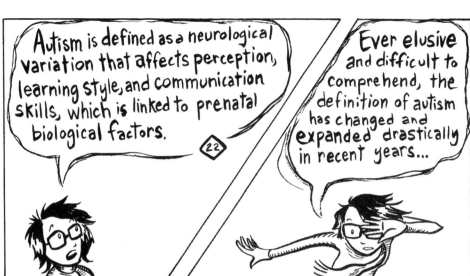

Autism is defined as a neurological variation that affects perception, learning style, and communication skills, which is linked to prenatal biological factors. [22]

Ever elusive and difficult to comprehend, the definition of autism has changed and expanded drastically in recent years...

Which may explain its increased presence in young people...

(Even though autism, like all of these variabilities, has always existed!)

Chances are you know someone with autism, or a learning disorder, or anxiety, or ADHD... or maybe that someone is YOU!

People with autism tend to be "left-brain" focused. They prefer logical facts and literal information.

$$S = \sqrt{\frac{\sum (x - \bar{x})^2}{n-1}}$$

Tigers give birth to 2 to 3 cubs every 3 years, with a gestation period of 104-106 days

People with autism also tend to have more difficulty with functions associated with the "right brain," such as adaptability in new situations and deciphering meaning from non-literal formats.

Now, this doesn't mean that every person with autism reacts this way; it's just a noticeable and persistent feature.

totally shut down →

As they say, if you've met one person with autism...

you've met one person with autism.

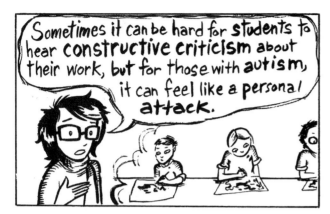

Sometimes it can be hard for **students** to hear **constructive criticism** about their work, but for those with **autism**, it can feel like a personal **attack**.

I always make sure to provide some positivity alongside suggestions...

And to be **super supportive** along the way...

But you know **what?**

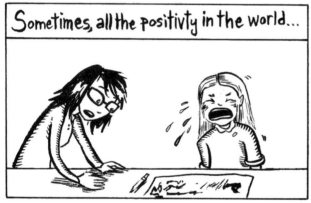

Sometimes, all the positivity in the world...

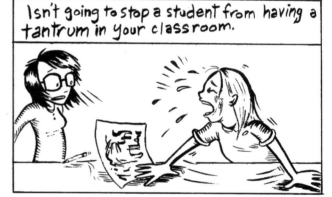

Isn't going to stop a student from having a tantrum in your classroom.

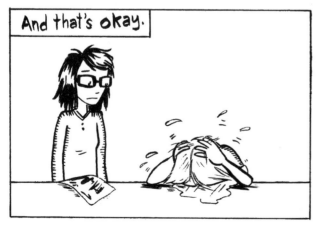

And that's **okay.**

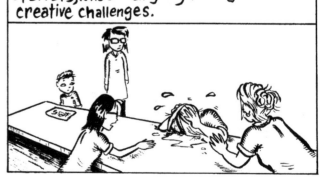

In the art room, you are working with a **community** of artists, who are all **going through their own** creative challenges.

There's a culture of support that naturally manifests...

and students can feel it the more they share with one another and work alongside each other.

With the identification of these complicated mental conditions becoming more prevalent, isn't it important now to focus on ways to strengthen imagination and creativity?

Art allows children to discover new abilities, which can be vital in a world of academic missteps and **learned helplessness.**

I think all of this evidence is telling us something... it's telling us that we need to **change.**

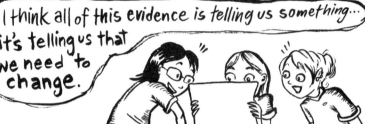

We need to change the way we think about what it means to be a **student** in school, what it means to learn, to be assessed...

what it means to be **successful.**

look! I made this! It's so great, isn't it?

We must meet students where they are!

While we as a **society** work to adopt new strategies to reach all *young people,* art can be a great support in building **community, confidence, and compassion!**
Even if you **aren't** an art teacher, you can still include **hands-on projects,** group collaboration, even **casual doodling** in your curriculum, and see the climate of classroom shift. **It is important** for students to know that they have **permission** to be creatively free, and respectably heard in a safe and supportive environment. Often, the biggest obstacle students have is **themselves.** Once they get past their feelings, they should be able to succeed in school and beyond, **right?**

who is education for, anyway?

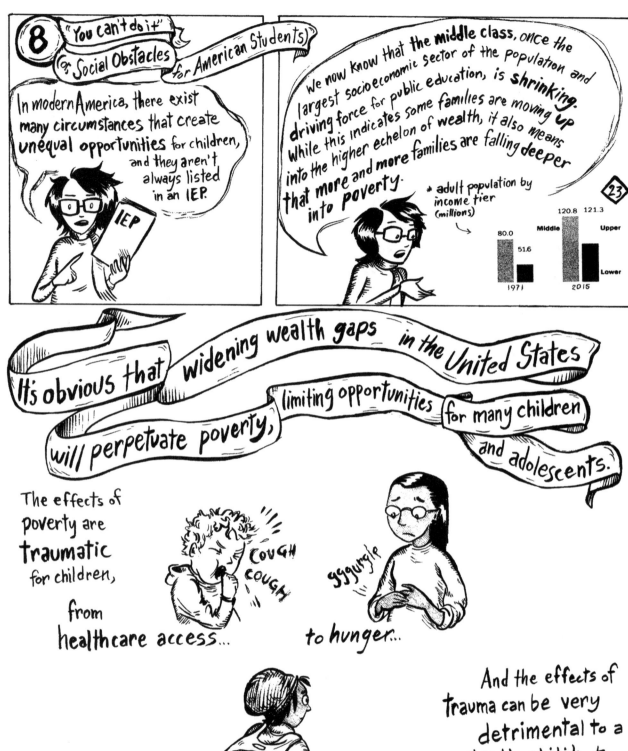

8 "You can't do it" or Social Obstacles (for American Students)

In modern America, there exist many circumstances that create **unequal opportunities** for children, and they aren't always listed in an IEP.

We now know that **the middle class**, once the largest socioeconomic sector of the population and driving force for public education, is **shrinking**. While this indicates some families are moving **up** into the higher echelon of wealth, it also means that **more and more** families are falling **deeper** into **poverty**.

㉓

* adult population by income tier (millions)

80.0 | 51.6 | 120.8 | 121.3
Middle | | Upper | Lower
1971 | | 2015

It's obvious that **widening wealth gaps** in the United States will perpetuate **poverty**, limiting opportunities for many children and adolescents.

The effects of poverty are **traumatic** for children,

from **healthcare access**...

COUGH COUGH

ggurgle

to hunger...

to homelessness.

And the effects of **trauma** can be very **detrimental** to a child's ability to learn and grow.

How do you support kids with the most need?

How do you step back but also step up?

How do you teach kids about the "power games in modern life"? Or about their place within the social hierarchy?

How do you motivate students to do more when they feel hopeless?

How do you involve students' communities and families in real, sustainable, and effective ways?

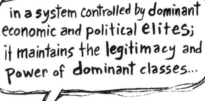

Here's what esteemed sociologist John W. Meyer says about education: "Education is seen as maintaining discipline and order...

in a system controlled by dominant economic and political elites; it maintains the legitimacy and power of dominant classes...

and effectively controls the lower classes." 24

Ugh.

UGH! GROSS.

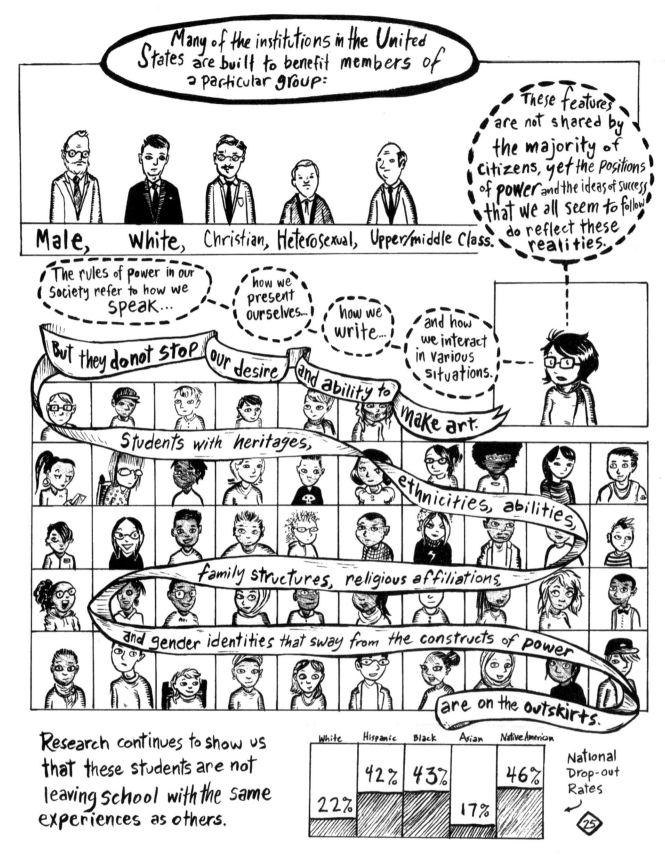

Many of the institutions in the United States are built to benefit members of a particular group:

Male, White, Christian, Heterosexual, Upper/middle Class.

These features are not shared by the majority of citizens, yet the positions of power and the ideas of success that we all seem to follow do reflect these realities.

The rules of power in our society refer to how we speak...

how we present ourselves...

how we write...

and how we interact in various situations.

But they do not stop our desire and ability to make art.

Students with heritages, ethnicities, abilities, family structures, religious affiliations, and gender identities that sway from the constructs of power are on the outskirts.

Research continues to show us that these students are not leaving school with the same experiences as others.

White	Hispanic	Black	Asian	Native American
22%	42%	43%	17%	46%

National Drop-out Rates ← 25

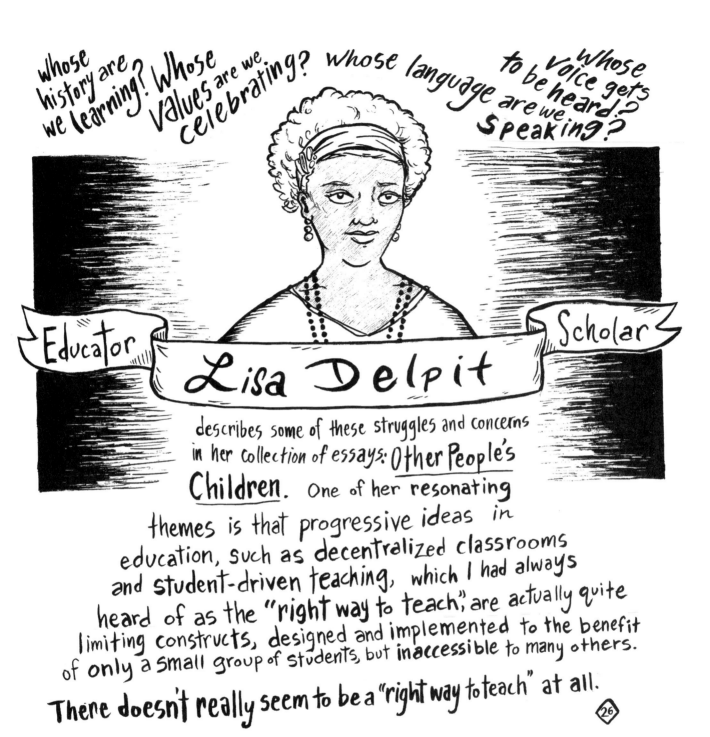

whose history are we learning? Whose values are we celebrating? whose language are we speaking? whose voice gets to be heard?

Educator

Scholar

Lisa Delpit

describes some of these struggles and concerns in her collection of essays: Other People's Children. One of her resonating themes is that progressive ideas in education, such as decentralized classrooms and student-driven teaching, which I had always heard of as the "right way to teach", are actually quite limiting constructs, designed and implemented to the benefit of only a small group of students, but inaccessible to many others.

There doesn't really seem to be a "right way to teach" at all. ㉖

"Being oppressed means the absence of choices." —bell hooks ㉗

Is equality in education a myth?

Responding to the cultural rules of power can be uncomfortable, and many non-minority teachers tend to downplay them in the classroom.

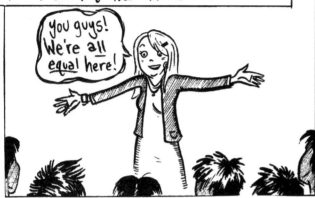

You guys! We're all equal here!

But this kind of color blind reaction will not change the rules of power, because it doesn't give students the opportunity to explore and understand these ideas.

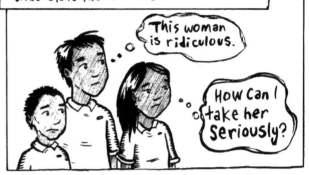

This woman is ridiculous.

How can I take her seriously?

Delpit writes,

"I further believe that to act as if power does not exist is to ensure that the power status quo remains the same." [28]

Why doesn't she just **talk** to us?

Right?

I feel so yucky.

I just feel so uncomfortable!

I don't want to say anything...

It's not my place.

Racism, sexism, and elitism in education can be defined by ignoring or choosing not to respond appropriately to the concerns of less-empowered groups. **Whether deliberate or not, there are still many areas of discussion that must be addressed to move forward in creating a truly equal and equitable public school system.**

You can't make **waves** without rocking the boat...

You can't shake up the system without having constructive, important, and sometimes difficult conversations.

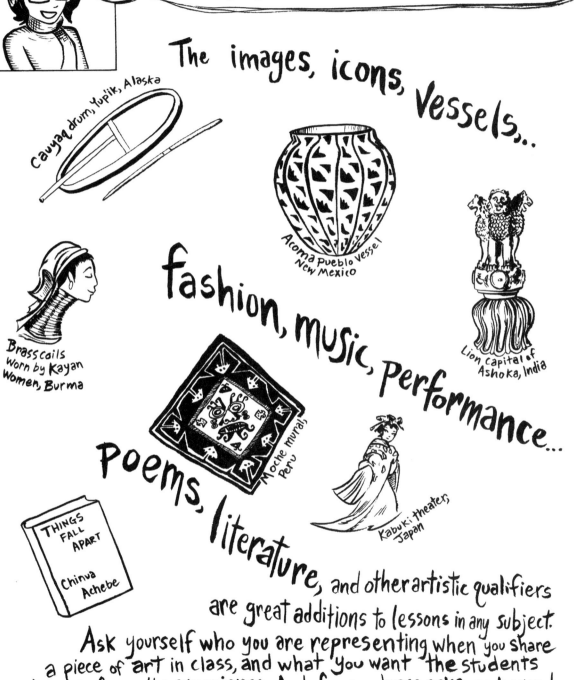

If you're feeling a little nervous about having challenging conversations, let art help you out!

The images, icons, vessels...

Cauyaq drum, Yupik, Alaska

Acoma Pueblo Vessel, New Mexico

Lion capital of Ashoka, India

Brass coils worn by Kayan Women, Burma

fashion, music, performance...

Moche mural, Peru

Kabuki theater, Japan

poems, literature,

THINGS FALL APART

Chinua Achebe

and other artistic qualifiers are great additions to lessons in any subject. Ask yourself who you are representing when you share a piece of art in class, and what you want the students to get from the experience. And for goodness sake, go beyond the obvious! (There's more to Mexico than Dia de los Muertos and Frida Kahlo, you know!)

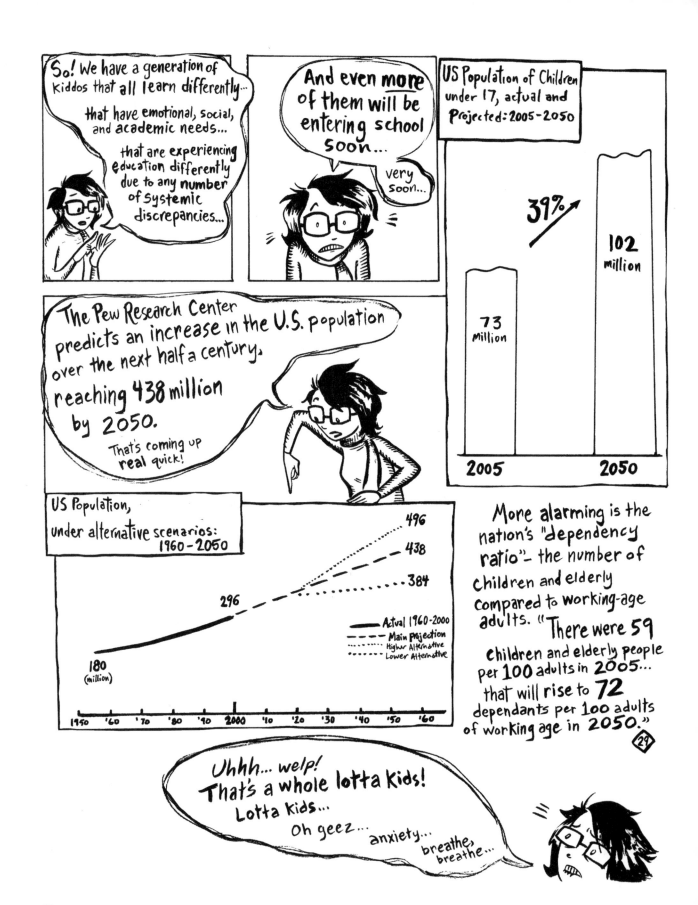

Look, 21st century students are the same kids we've always known.

They'll have the same interests...

Ooooo... hunky!

♥ TEEN HUNKS ♥

the same mood swings...

I HATE EVERYONE! Where are the OREOS?! I'm starving!

the same skin problems.

Oreos, you have betrayed me...

As educators, we must be ready to finesse complicated situations with them, for them, and to accept these children for **who they are**.

Are you prepared, educators?

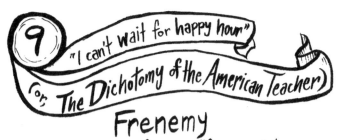

9 "I can't wait for happy hour"
(or, The Dichotomy of the American Teacher)

Frenemy

Noun, informal. /ˈfrenami/

Definition: A person who pretends to be a friend, but is actually an enemy. ㉚

Okay, it might feel a little **rude** starting **this chapter** with the word "frenemy," but hear me out.

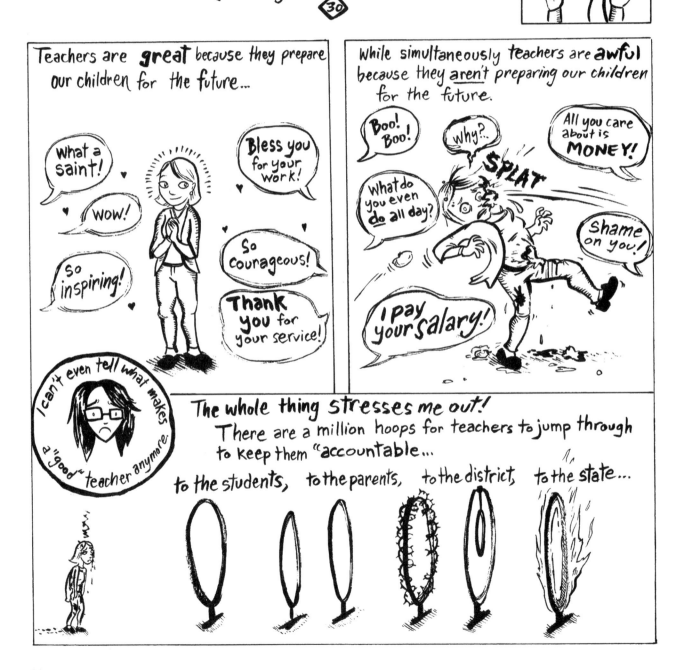

Teachers are **great** because they prepare our children for the future...

What a saint!

Wow!

So inspiring!

Bless you for your work!

So courageous!

Thank you for your service!

While simultaneously teachers are **awful** because they <u>aren't</u> preparing our children for the future.

Boo! Boo!

Why?...

All you care about is **MONEY!**

What do you even <u>do</u> all day?

SPLAT

Shame on you!

I pay your salary!

I can't even tell what makes a "good" teacher anymore

The whole thing stresses me out!
There are a million hoops for teachers to jump through to keep them "accountable...

to the students, to the parents, to the district, to the state...

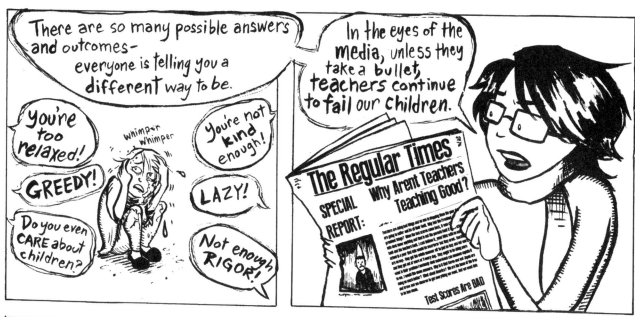

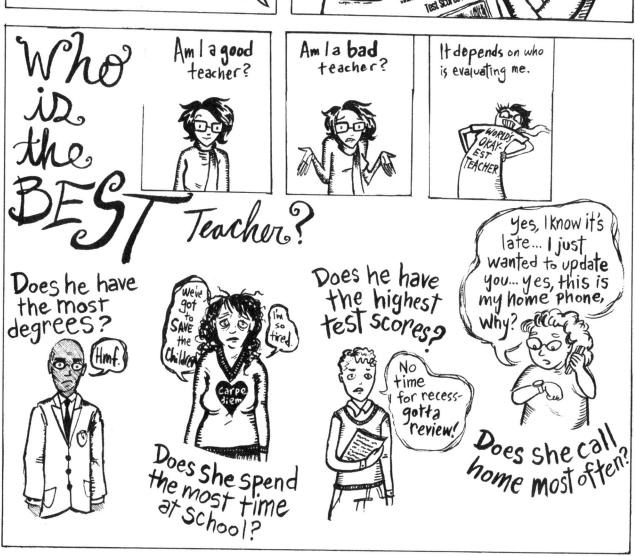

What other profession expects this much from you — emotionally, mentally, physically — with so little to show for it?

oh, woe!

oh, sorrow!

Well, social work and nursing, to name a couple.

BUT STILL!

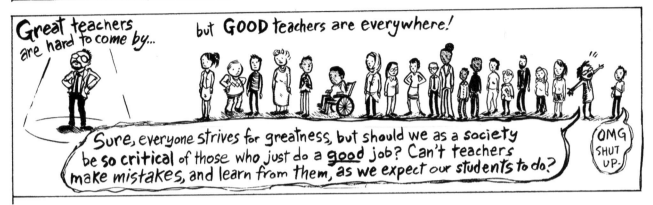

Great teachers are hard to come by...

but GOOD teachers are everywhere!

Sure, everyone strives for greatness, but should we as a society be so critical of those who just do a good job? Can't teachers make mistakes, and learn from them, as we expect our students to do?

OMG SHUT UP.

One year, I taught AP 2-D Design Studio Art to highschool kids.

So official.

AP Studio Art GUIDE

On their final report cards, every student passed, because they all achieved notable artistic and personal growth.

However, their portfolio grades, from the College Board, said otherwise...

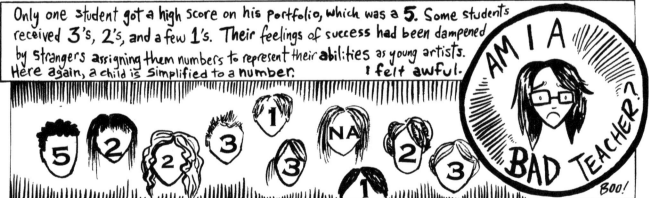

Only one student got a high score on his portfolio, which was a 5. Some students received 3's, 2's, and a few 1's. Their feelings of success had been dampened by strangers assigning them numbers to represent their abilities as young artists. Here again, a child is simplified to a number. I felt awful.

AM I A BAD TEACHER?

BOO!

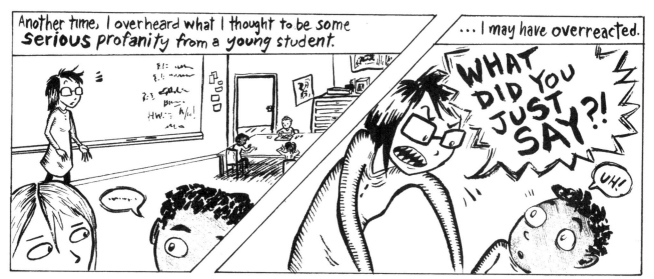

Another time, I overheard what I thought to be some **serious** profanity from a *young* student.

... I may have overreacted.

WHAT DID YOU JUST SAY?!

UH!

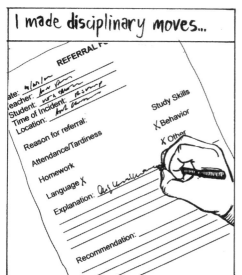

I made disciplinary moves...

REFERRAL F...

ate:
eacher:
Student:
Time of Incident:
Location:

Reason for referral:

Attendance/Tardiness

Homework

Language X

Explanation:

Study Skills

X Behavior

X Other

Recommendation:

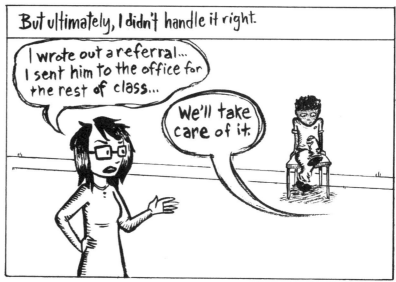

But ultimately, I didn't handle it right.

I wrote out a referral... I sent him to the office for the rest of class...

We'll take care of it.

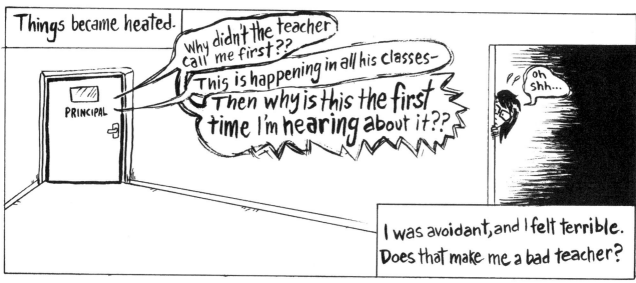

Things became heated.

PRINCIPAL

Why didn't the teacher call me first??

This is happening in all his classes—

Then why is this the first time I'm hearing about it??

oh shh...

I was avoidant, and I felt terrible. Does that make me a bad teacher?

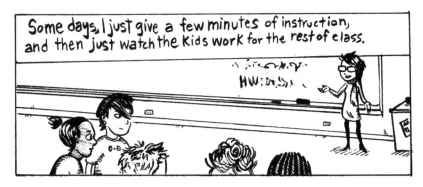

Some days, I just give a few minutes of instruction, and then just watch the kids work for the rest of class.

I just stand there until they need something.

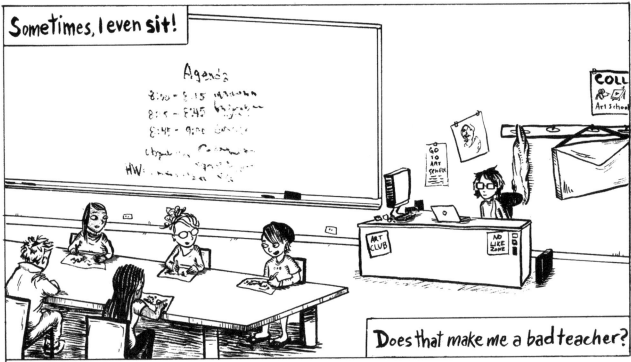

Sometimes, I even **sit!**

Does that make me a bad teacher?

Sometimes, students talk me into changing a grade or two.

Ms. B, I saw I got a **zero** for the homework two weeks ago, but I turned it in.

I don't **want** to be a pushover...

Yes, and you turned it in **late**—two weeks late.

But I also don't want to be **a bad teacher.**

Buuut I guess you deserve partial credit for completing it. Let's check the gradebook!

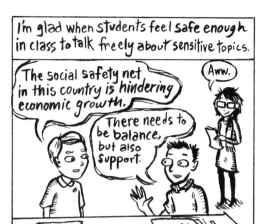

I'm glad when students feel **safe enough** in class to talk freely about sensitive topics.

The social safety net in this country is hindering economic growth.

Aww.

There needs to be balance, but also support.

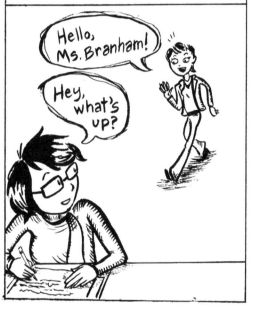

When a student went to the assistant principal, saying I had "discriminated against him"...

Hello, Ms. Branham!

Hey, what's up?

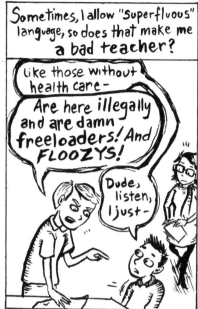

Sometimes, I allow "superfluous" language, so does that make me **a bad teacher?**

Like those without health care—

Are here illegally and are damn **freeloaders!** And **FLOOZYS!**

Dude, listen, I just—

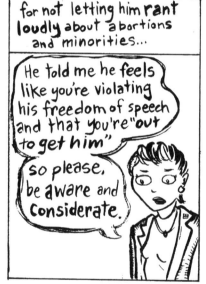

for not letting him **rant loudly** about abortions and minorities...

He told me he feels like you're violating his **freedom of speech** and that you're "out to get him"

So please, be **aware** and **considerate.**

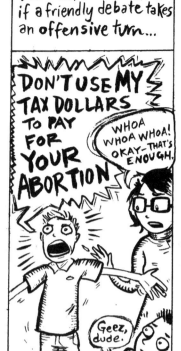

I will shut a conversation if a friendly debate takes an **offensive turn...**

DON'T USE MY TAX DOLLARS TO PAY FOR YOUR ABORTION

WHOA WHOA WHOA! OKAY— THAT'S ENOUGH.

Geez, dude.

Well, that time I knew I wasn't a bad teacher... just a **confused** teacher.

...Sure.

In whose eyes are teachers "good" or "bad"?

Whose eyes matter?

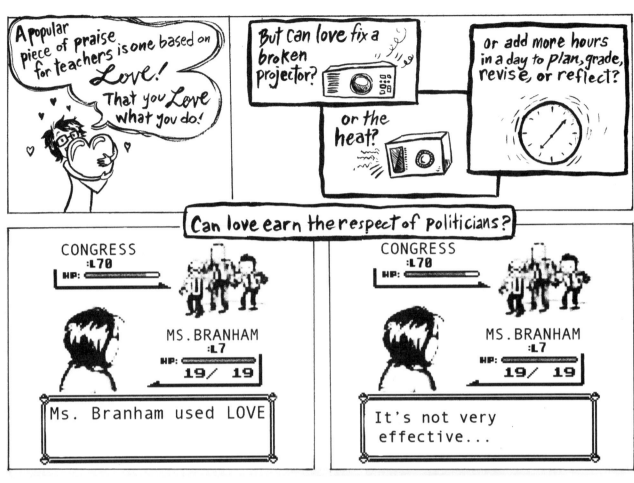

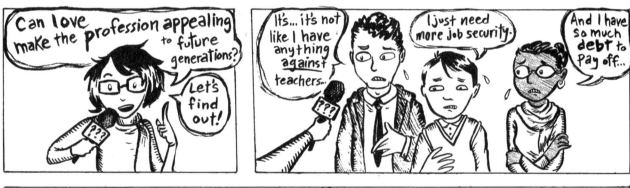

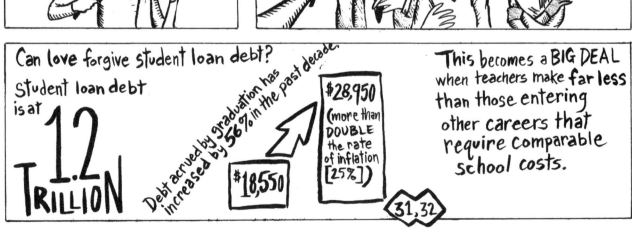

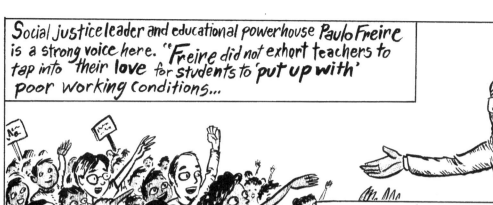

Social justice leader and educational powerhouse *Paulo Freire* is a strong voice here. "*Freire did not exhort teachers to tap into their* **love** *for students to* '**put up with**' *poor working conditions...*

He said that teachers cannot teach well because of low salaries and lack of respect and that we have to **fight against this** every step of the way." ⟨33⟩

But he's dead, so...

I watched this documentary called *The War on Kids*

Ooooh— sounds SHOCKING!

THE WAR ON KIDS

In it, a scruffy teenager told the camera:

Bottom line: teachers need to love kids and love teaching kids

BAND

It's the same rhetoric we've heard before, but then I thought

What exactly do you mean, "love"?

Educator Garrett Keizer remarks that he can't say with any conviction that he "loves teaching"

but that he loves his *individual students* in ways that are deeply and personally **moving**.

Yes. Totally.

If you love **what** you teach, and **who** you teach, then you are a good teacher.

When you continue to learn alongside your students, then you are a **good** teacher. If you don't love learning, your students won't either.

95

What I've learned in my few years of teaching is that you can't expect anything to be easy, and you can't expect other people to agree with you on priorities.

I mean, of **course** children are the priority... but what's more important:

Sports or Arts?

A Pep Rally or A Science Fair?

A College Tour or A Visiting Artist?

When it comes to creating your school culture, the power of the teacher must be greater than the administration.

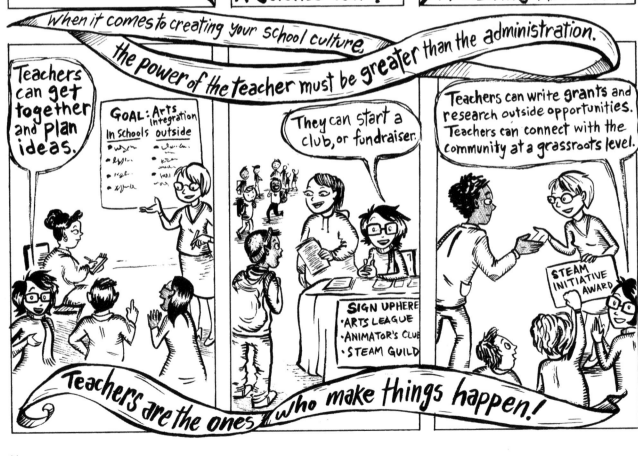

Teachers can get together and plan ideas.

GOAL: Arts Integration
In Schools / outside

They can start a club, or fundraiser.

SIGN UP HERE
• ARTS LEAGUE
• ANIMATOR'S CLUB
• STEAM GUILD

Teachers can write grants and research outside opportunities. Teachers can connect with the community at a grassroots level.

STEAM INITIATIVE AWARD

Teachers are the ones who make things happen!

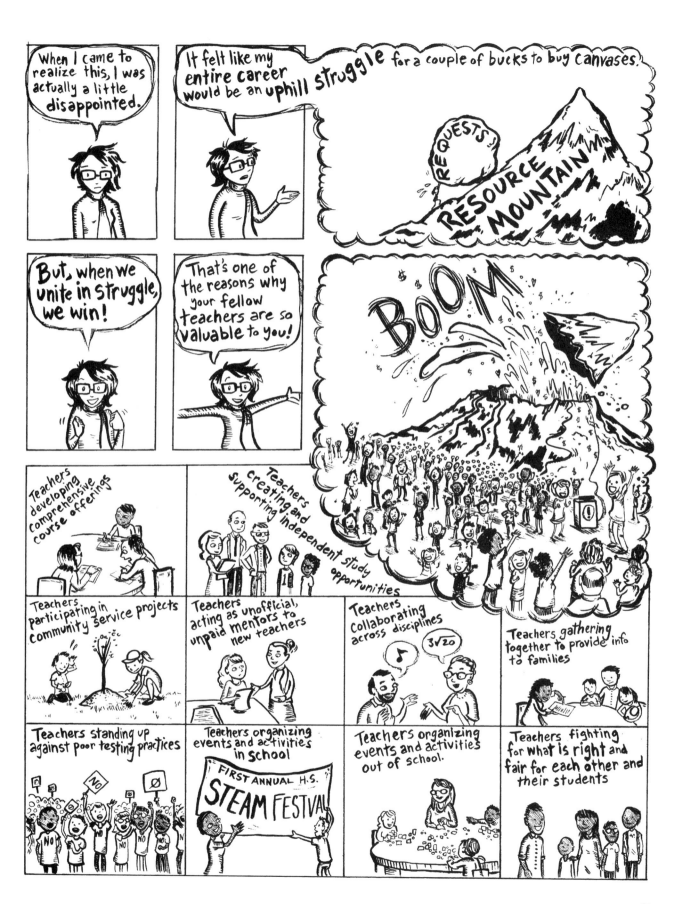

Real-life teaching isn't at all what they make it seem like in the movies. Maybe someday they'll make an overly dramatized movie about my teaching career.

A beautiful actor would play me. It would be all kinds of inspiring and emotional, and in the end, this radical educator just ain't gonna take it no mo'!

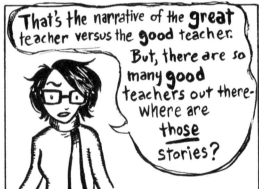

That's the narrative of the **great** teacher versus the **good** teacher. But, there are so many **good** teachers out there- where are those stories?

Thanks for staying after school so I could finish that project!

Any time!

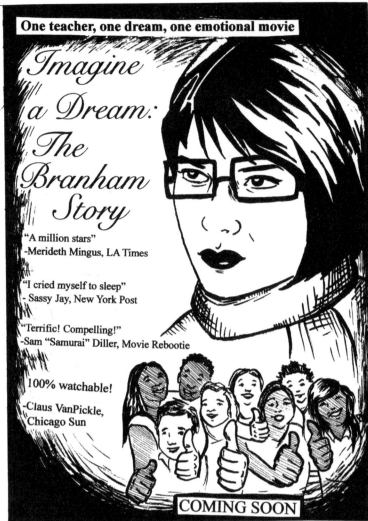

One teacher, one dream, one emotional movie

Imagine a Dream: The Branham Story

"A million stars"
-Merideth Mingus, LA Times

"I cried myself to sleep"
- Sassy Jay, New York Post

"Terrific! Compelling!"
-Sam "Samurai" Diller, Movie Rebootie

100% watchable!

-Claus VanPickle, Chicago Sun

COMING SOON

FUNDRAISER

UGH! I just can't deal with that class or this school or ANYTHING!

Why don't you just sit and draw a little until you feel ready to go back? You'll feel better.

Thanks, Ms. B!

Yeah, yeah, yeah... you're welcome.

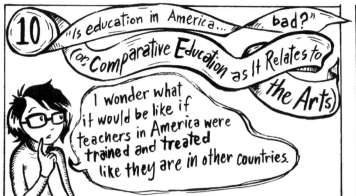

(10) "Is education in America... bad?"
(or *Comparative Education as It Relates to the Arts*)

I wonder what it would be like if teachers in America were trained and **treated** like they are in other countries.

When I was in grad school, I took a course in comparative education, and while it was a struggle for me—

hhhuuhwhah?

It really opened my eyes to how many different variables impact education.

Take Finland, for example.

The teachers are **so well-treated,** and the **parents** are so well-treated. If you get healthy parents and healthy teachers, put those **together** and what are you gonna get? Great kids! Awesomeness! And probably a great economy!

Yeah, what **she** said!

PISA: Preparing Students for Global Challenges

Finland has been receiving international acclaim by beating the pants off of other developed nations in the PISA test. PISA (Programme for International Student Assessment) was created to document the abilities of school-aged children around the world, noting the differences in problem-solving abilities, contextual understanding, and communication ability. This data collection system is not a "high-stakes test"; it is not designed to determine outcomes of each individual student, but rather to pinpoint the successes and challenges of each country's educational systems, as it relates to economic development.

The act of building the comprehensive school (or **peruskolu**) was the blueprint by which all other reform measures have been built.

Kannisto School (Looks pretty nice!)

This model of public schooling does not select its pupils by status, income, or ability, yet makes great strides in educating each child with the same opportunities for **sucess, self-actualization, and achievement.**

These schools also provide health and food services to students and families.

Pasi Sahlberg, former director of Finland's Center for International Mobility and Cooperation, describes several key themes from Finnish education: *less classroom-based teaching, more personalized learning, a focus on social skills, empathy and leadership, and an encouragement for students to discover their talents.*

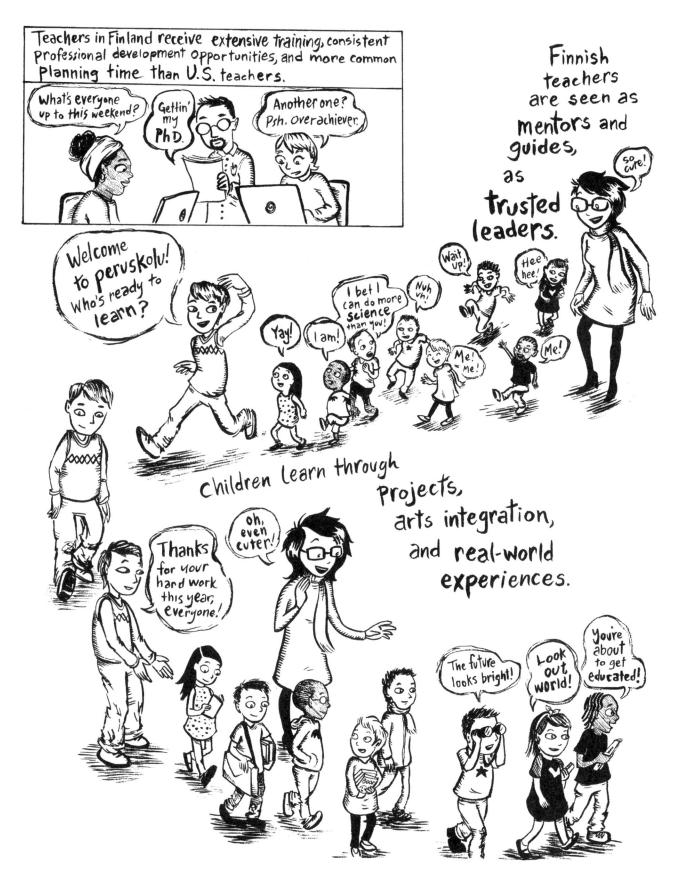

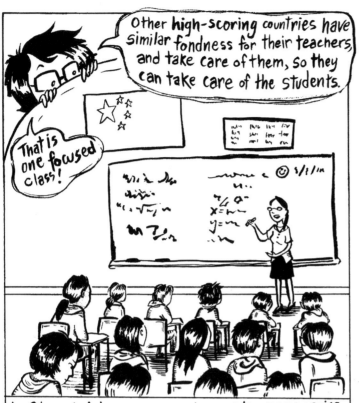

Other **high-scoring** countries have similar fondness for their teachers, and take care of them, so they can take care of the students.

That is one **focused** class!

In Shanghai, teachers spend **many hours** preparing for a single 45-minute class, because they have **much more** time to plan. They have time to craft complex questions and engaging activities, pushing their students in **critical thinking** and **creative problem-solving**.

In Singapore, teaching has **always been** seen as **highly respected** and prestigious.

In Canada, schools receive technical assistance and support from the government, not **threats** to **close**.

I'm so proud of those teachers!

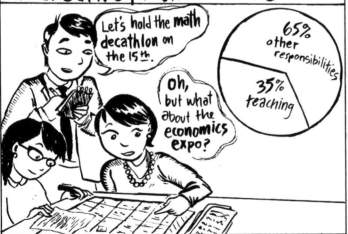

Let's hold the **math** decathlon on the 15th.

Oh, but what about the economics expo?

65% other responsibilities

35% teaching

In South Korea, 35% of teachers' time is spent in front of students, teaching. The rest of the time is spent planning, collaborating, and engaging in professional development activities.

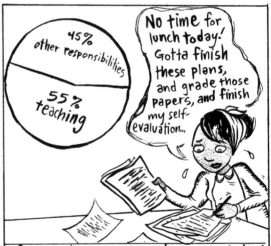

No time for lunch today! Gotta finish these plans, and grade those papers, and finish my self-evaluation...

45% other responsibilities

55% teaching

Comparatively, U.S. teachers spend about 55% of their time teaching, leaving much less time for effective planning and training.

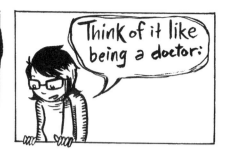

Many teachers in the United States, including myself, have far fewer years of training before entering the classroom for the first time — some even less than **one year!**

No big deal, you say?

Think of it like being a doctor:

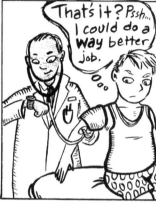

You've been to the doctor's before, so you have an idea about what it's like.

That's it? Pssh... I could do a **way** better job.

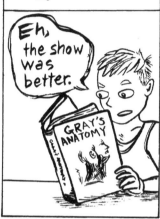

You take some classes on biology and anatomy...

Eh, the show was better.

GRAY'S ANATOMY

then soon you're doing your clinical residency...

YAWN let's get to the good stuff, already.

and suddenly you're in the operating room with a scalpel in your hand!

um...

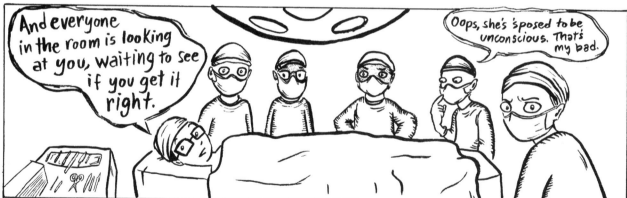

And everyone in the room is looking at you, waiting to see if you get it right.

Oops, she's 'sposed to be unconscious. That's my bad.

That's a pretty harsh metaphor, but there is some **truth to it!**

Feeling unprepared, uncertain, and without a safety net is a common occurrence for many teachers.

All you can do is read,

read,

read...

TEACH IT REAL GOOD

and reach out to other teachers, to stres out together?

NOOB TEACHER FORU

- What do I say?
- Where do I sit?
- Are the kids supposed to be so loud?
- What if I need to pee?

It can be assumed that when teachers are treated better, students tend to do better. And when students do better, they are more prepared to contribute to their society after they graduate.

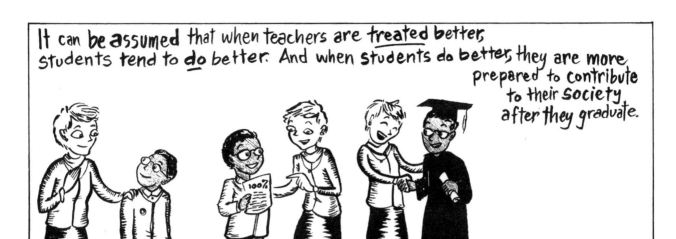

That all sounds great, but where does art fit in? Let's go back to Finland.

Finnish students have access to the arts through a variety of outlets. Students are taught to embrace the **uncertainty and EXPerimentation** associated with art-making, encouraging them to take risks and make decisions.

Art is considered **essential** for daily learning for all ages and ability levels.

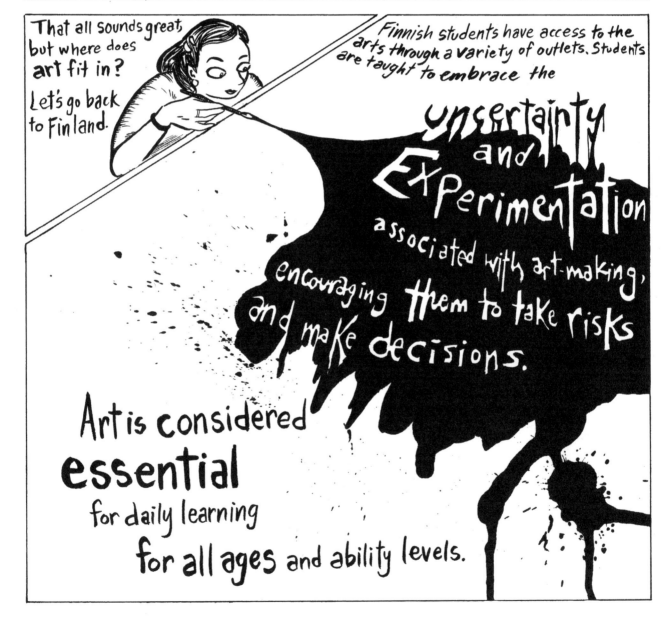

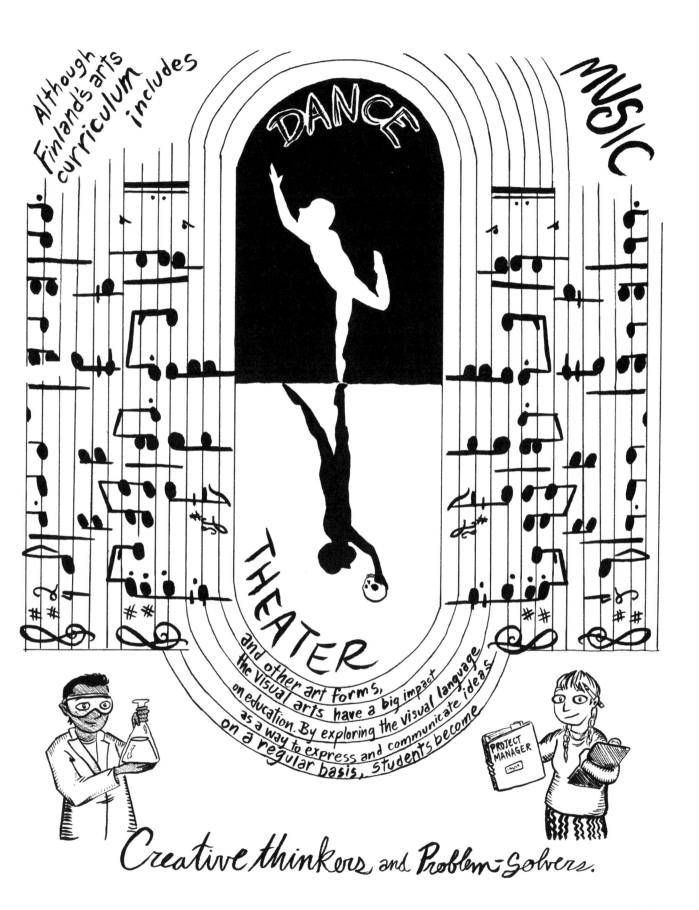

Although Finland's arts curriculum includes

DANCE

MUSIC

THEATER

and other art forms, the visual arts have a big impact on education. By exploring the visual language as a way to express and communicate ideas on a regular basis, students become

PROJECT MANAGER

Creative thinkers and Problem-Solvers.

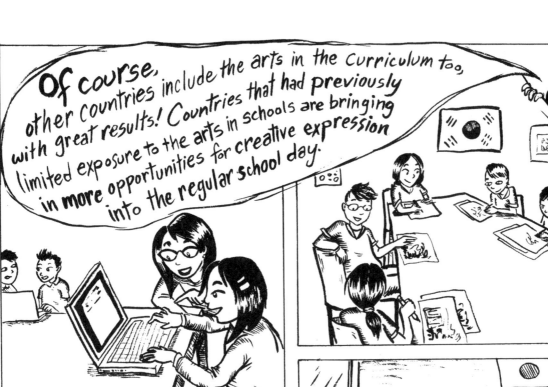

Of course, other countries include the arts in the curriculum too, with great results! Countries that had previously limited exposure to the arts in schools are bringing in more opportunities for creative expression into the regular school day.

In Japan, known for rigorous academics, students take art, music, and physical education seriously. Students spend a lot of time developing their skills throughout their school careers.

South Korea's goals for education include, in addition to academic knowledge and applied skills, **emotional skills** and self-awareness, **creative/aesthetic** sensibilities, spiritual well-being, and other activities that build **tolerance** and respect for others.

㉟

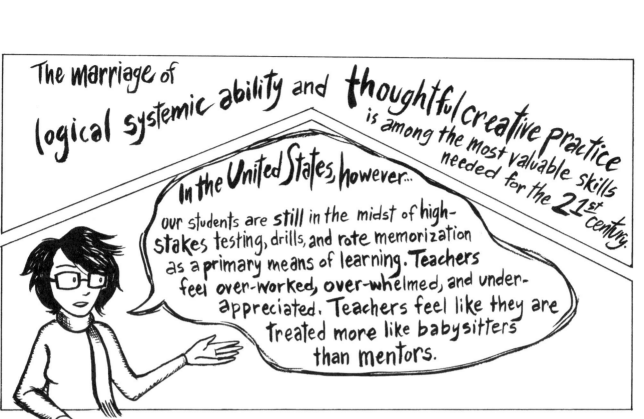

The marriage of logical systemic ability and thoughtful creative practice is among the most valuable skills needed for the 21st century.

In the United States, however... our students are still in the midst of high-stakes testing, drills, and rote memorization as a primary means of learning. Teachers feel over-worked, over-whelmed, and under-appreciated. Teachers feel like they are treated more like babysitters than mentors.

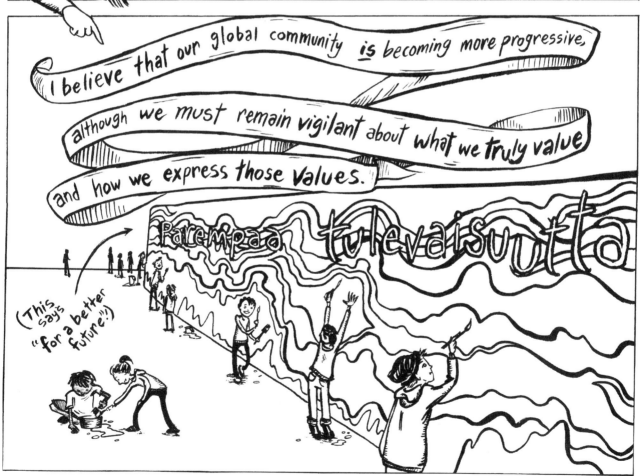

I believe that our global community is becoming more progressive, although we must remain vigilant about what we truly value and how we express those values.

Parempaa tulevaisuutta

(This says "for a better future!")

Yes, like many professionals, I want to be **great** at what I do. I want be a great teacher someday, **but I won't get there by doing all the talking.**

There is **no** way...

NO WAY EVER

that I'll be able to **truly** understand what my students go through. I can't pretend to know what's **best for them,** or that somehow I can **save** them from **social, moral, or physical ills.**

You know nothing, Rachel Branham

What I **can** do is be **open** and sensitive to their needs, identities, and interests...

and encourage them to use **art to tell their stories.**

SNIFF

I can make it my business to **talk** with students, to **hear** and **see** what they have to say...

and have **conversations** that help them to feel confident about expressing themselves and **exploring** ideas.

So, you better believe

I'm taking Finland's example **seriously.**

I can make **concerted efforts** to communicate with families – bring them into the schools, too, and create **parterships** that are **real,** not just for face-value.

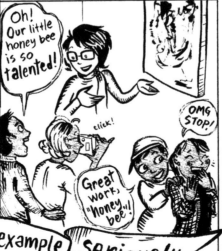

Oh! Our little honey bee is so talented!

click!

Great work, "honey bee"!

OMG STOP!

This is something that **all** teachers **can do,** and it will help put us in a **place of holistic education** for every child that is nurturing, supportive, and honest.

sit with me,
not in front of me.

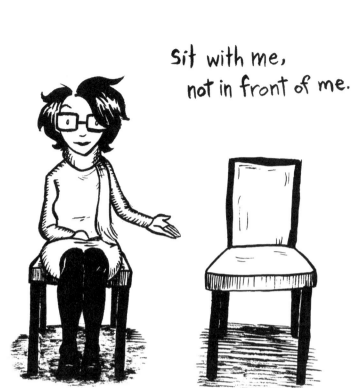

This is an important time for art to take center stage!

...no pun intended.

(maybe.)

Performance, visualization, and craftsmanship — these are all ways for students to vocalize their challenges, inequities, and struggles, both perceived and actual. The only limit now is ourselves.

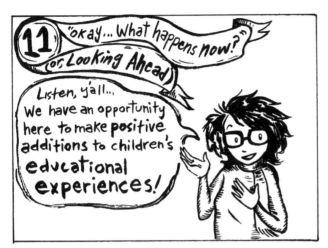

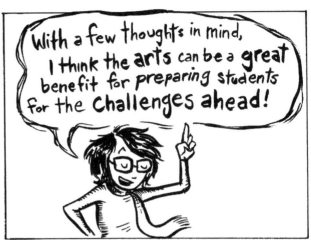

"For America's young people to be fully prepared when they leave high school for college, career, and life, they will need a complete and competitive education. They will need an education that includes deep, expansive knowledge in a broad range of subjects, as well as reading, writing, and computational skills.

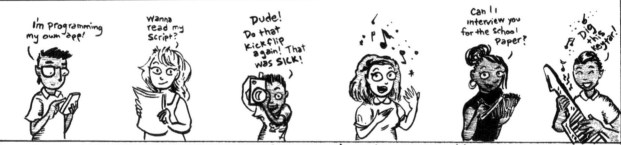

They will need the ability to think creatively and synthesize relevant information from across subject areas and combine it in new and novel ways. And they will need the ability to reason analytically, communicate effectively, and work collaboratively. In other words, they will need the knowledge, skills, and competencies that the arts teach!"

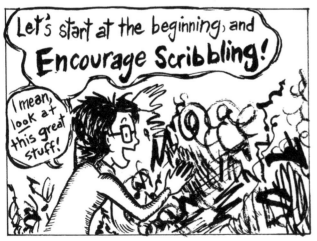

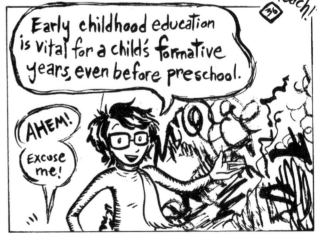

You already know about Lowenfeld's stages, so you know that drawing is **crucial** for children's development. If you teach young children, or have some of your **own**, do some **drawings** with them! Make **drawing** and **play** a part of **every day**!

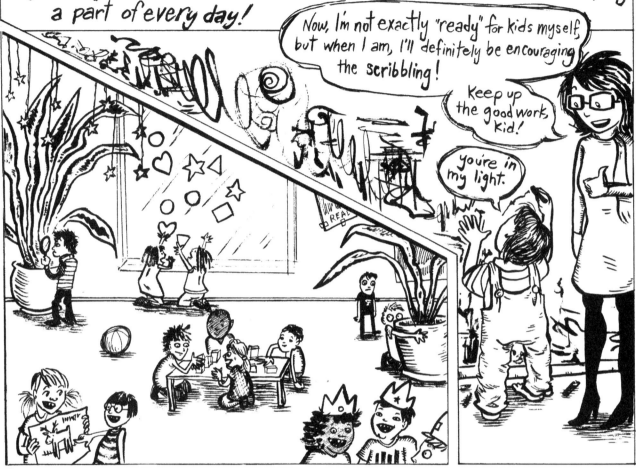

Now, I'm not exactly "ready" for kids myself, but when I am, I'll definitely be encouraging the scribbling!

Keep up the good work, kid!

you're in my light.

There are **many** opportunities to focus through the arts lens to aid in reading skills — one of the most valuable skills a child can learn.

WOW, so pretty!

The Rainbow Bird in the Big Forest

Exposing little kiddos to art is **great** for literacy!

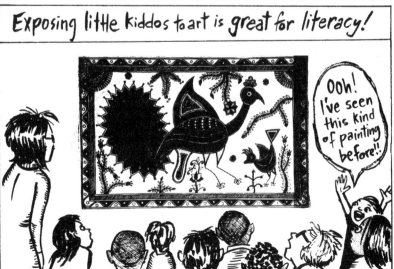

Ooh! I've seen this kind of painting before!

A book's images are what **always** engage children in reading first.

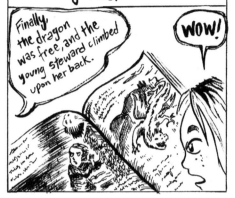

Finally, the dragon was free, and the young steward climbed upon her back.

WOW!

Hearing the story while looking at the images **strengthens** the imagination!

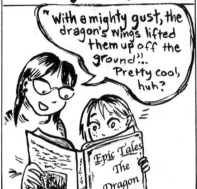

"With a mighty gust, the dragon's wings lifted them up off the ground"... Pretty cool, huh?

Epic Tales The Dragon

As a child sees the images and the text, along with the sounds of the story, he or she begins to create **connections** from spoken word to written words.

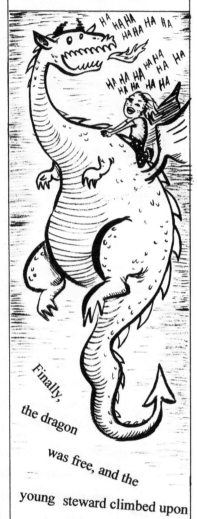

HA HA HA HA HA HA
HA HA HA HA HA HA HA HA HA HA

Finally, the dragon was free, and the young steward climbed upon her back. With a mighty gust, the dragon's wings lifted them off the ground, flying high into the sky. Together, there was no foe they could not beat, no battle they could not win!

Back to drawing: mark-making helps develop **print awareness** in young children.

What are you working on, honey?

I'm writing the next chapter in the story!

...you gonna clean your room after?

Nope!

Using lines and shapes to communicate eventually leads to reading and **writing in an established language. See?**

Observations and discussions about art improve language and communication abilities, too. These are all opportunities for incidental learning, creating a foundation of understanding and investigation.

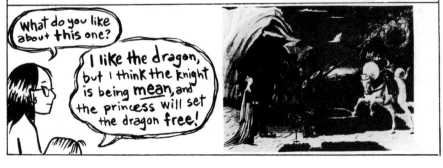

What do you like about this one?

I like the dragon, but I think the knight is being **mean**, and the princess will set the dragon **free!**

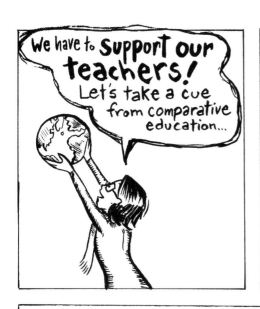

We have to **support our teachers!** Let's take a cue from comparative education...

and prepare our college students to become stronger educators with greater support.

This can be accomplished with **University Programs** and **Professional development.**

University Programs

are the **first step** in developing a teachers awareness, sensibility, and pedagogical philosophies.

In Finland, teaching is a highly selective field, and only the most talented applicants are accepted into multi-year teaching programs (often with scholarships!)

Teaching is **exclusive** and prestigious, because teachers are treated more **fairly** and respectfully — and wages are comparable to other prestigious occupations, like lawyers, doctors, and engineers.

There's **no shortage** of teachers in countries who have invested in their training and ongoing support.

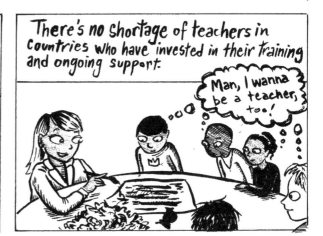

I've seen a lot of friends, mentors, colleagues, and even my own former teachers leave the field quickly—

Some within a few years of certification, others after confronting the new reality of increased testing...

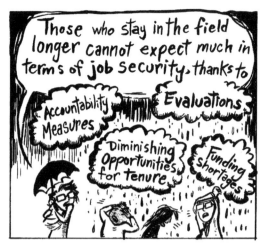

Those who stay in the field longer cannot expect much in terms of job security. thanks to

Accountability Measures

Evaluations

Diminishing Opportunities for tenure

Funding shortages

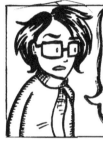

When schools lose teachers, they are also losing part of the community. Students lose support, trust, and hope...

I guess NO ONE wants to teach us...

Man, I thought she really liked us!

Well, whatever!... I don't care!

≥sniff≥ I'm not crying, you're crying!

In order to create stability and staying power, how we treat and train our teachers must be changed!

Professional Development (or PD)

refers to ongoing teacher training that occurs within the teaching practice. Sometimes, PD can be **isolating**, *ineffective*, and **expensive.**

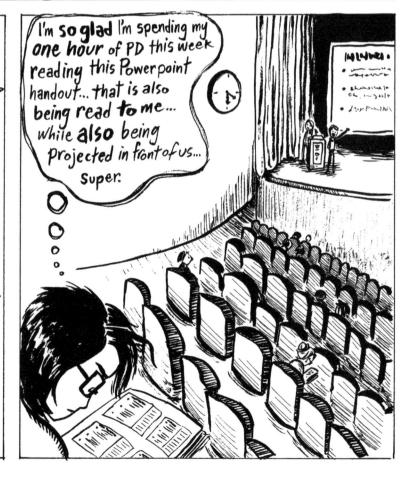

I'm **so glad** I'm spending my one hour of PD this week reading this Powerpoint handout... that is also being read **to me**... while **also** being projected in front of us... super.

115

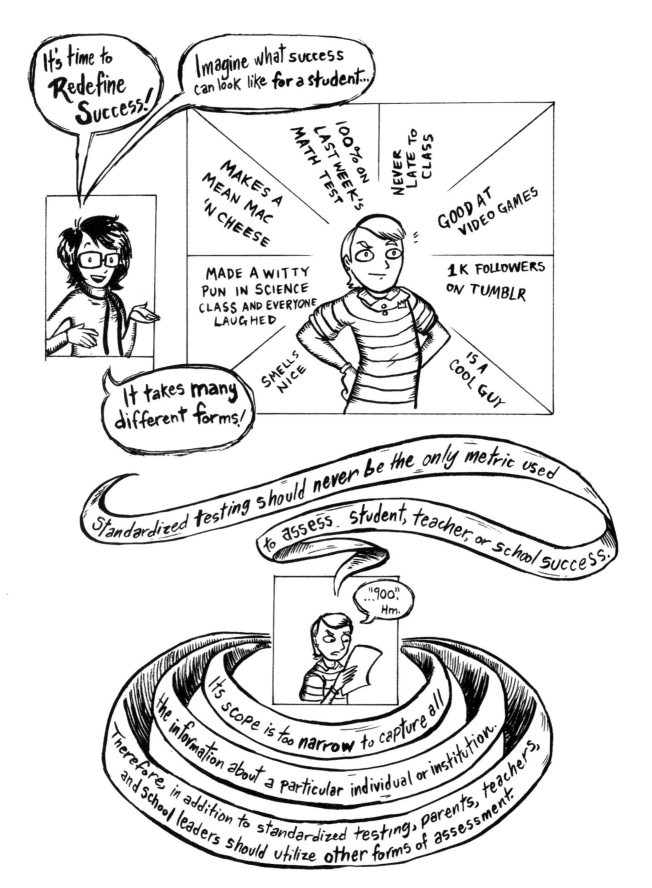

Portfolios, Capstone Projects, and Performance-based Assessments

should be considered and implemented in every school.

Why? Well, although these assments take more time and more work to complete, they reveal a lot of **useful** information about **student learning!**

A **portfolio** refers to a **body of work**, collected over a certain period of time, documenting a student's progression in an area of study using indicators of growth and development.

Portfolios can be created in any class, but they are a natural fit in the art classroom. Simply by accumulating artwork, students can **review** and **assess** their improvement by actually **seeing** their progress in front of them. They have evidence to **defend** and **support** their abilities as artists and scholars.

Capstone Projects are culminating assignments that synthesize information into a final piece. This could be a painting or sculpture, but why not a play? Or a data review? Or a business proposal with projected revenue? (I'm a poet and I don't know it!)

Using the Creative Process, capstone projects build upon skills and ideas to showcase higher-order thinking!

- evaluation and reflection
- brainstorming
- development/execution
- The Creative Process
- research and planning
- responding to feedback
- experimentation

Performance-based assessments involve student participation and action, and can revolve around **giving a presentation**, solving specific problems, or explaining a theory or idea.

And that is why the original recipe is the superior chicken recipe.

Any questions?

For visual arts, students must engage in the action of creating an artwork, like a drawing or print. The creation of the artwork is only part of the assessment— the resulting piece and the critique about it, which the student and the peers both **analyze** and **discuss**, is another vital component, just as it is with the rest of the assessments.

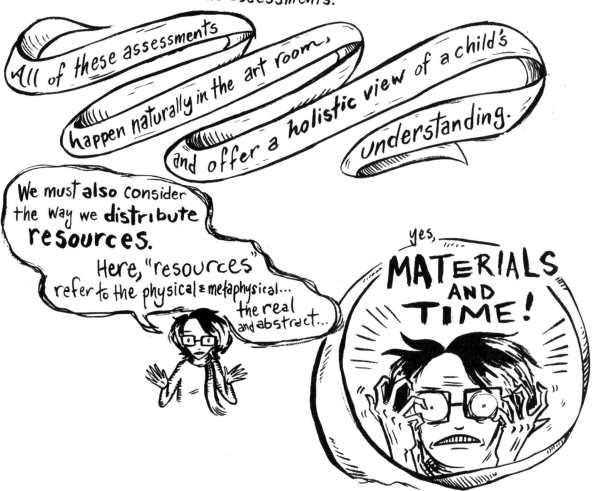

All of these assessments happen naturally in the art room, and offer a holistic view of a child's understanding.

We must also consider the way we **distribute** **resources.**

Here, "resources" refer to the physical & metaphysical... the real and abstract...

yes,

MATERIALS AND TIME!

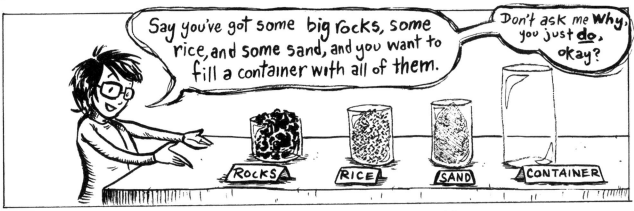

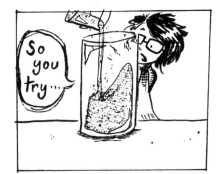

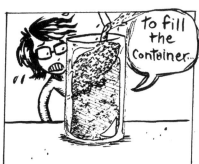

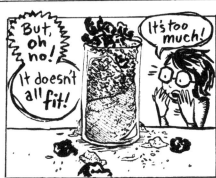

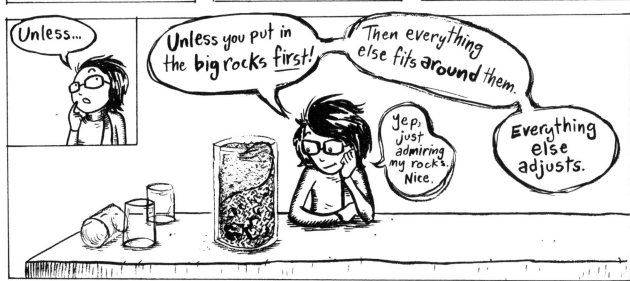

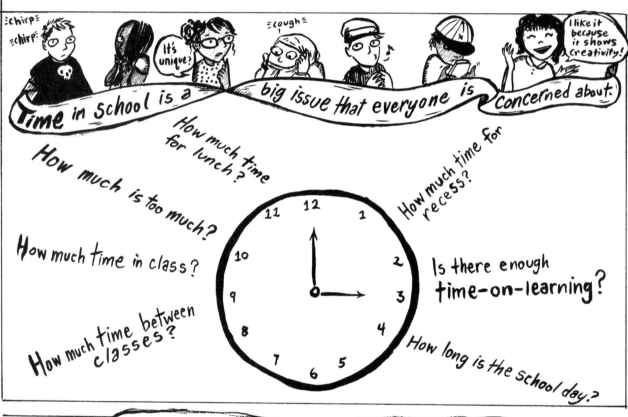

What does it mean to **cultivate passion?** What does "life-long learning" look like? Simply, it's the desire to continue improving, gaining insight, and overcoming obstacles.

Alright! I made it!

First art teacher on this metaphorical mountain!

Remember the PISA test? It is (theoretically) designed to measure students' critical thinking and **problem-solving abilities,** and capacity for **life-long learning** —

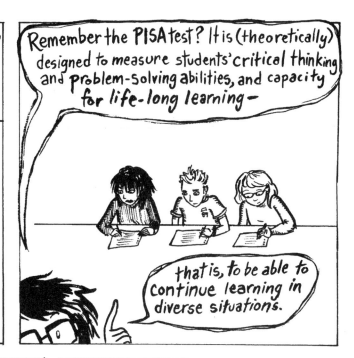

that is, to be able to continue learning in diverse situations.

When the United States performs **poorly** or **averagely** on these tests, it can be assumed that our students are **not excited** or **confident** about learning and continuing to learn, or expanding their opportunities later in life.

BORED...

This sucks...

Hungry!

Let's talk about **ELO's,** or Expanded Learning Opportunities. They're exactly what they sound like— great additions to a child's educational experiences that build on **their interests!**

Social media...

Fitness...

Mac 'n cheese...

Sigh

ELO's can be offered in school, at local businesses, or in **community spaces.**

MARKETING FIRM

Wow! 25 new users!

Nice job!

Arts-integrated or arts-based **ELO's** can encourage students...

KIDS RELAY

Alright!

towards their college, career, and citizenship goals.

Oh, it's just so beautiful!

When I was a graduate student, I helped run an ELO with students from a local high school, who would be driven to the Rhode Island School of Design campus...

and work on thematic art projects using the school's resources. During our first semester, the high school students designed pages for individualized art books.

For each page of their book, they created an artwork in response to a prompt about the idea of "power." Their resulting books contained varying experiences and reactions and of course beautiful drawings and paintings!

In the second semester, after surveying the high school students' interests and helping them to develop project proposals...

I paired them with RISD undergraduate students in specific majors, from fashion design to photography, to help them execute their goals.

This process allowed the high school kiddos to cultivate a passion and explore new arenas of the arts that may not have been available to them, with a variety of mentors and materials at their disposal.

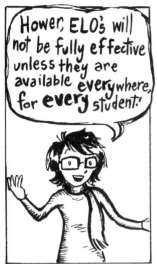

However, ELO's will not be fully effective unless they are available **every**where, for **every** student.

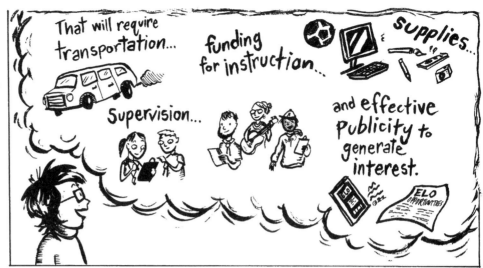

That will require transportation... funding for instruction... supplies... Supervision... and effective publicity to generate interest.

Creating and sustaining ELO's is a **huge** and **expensive** undertaking, I know...

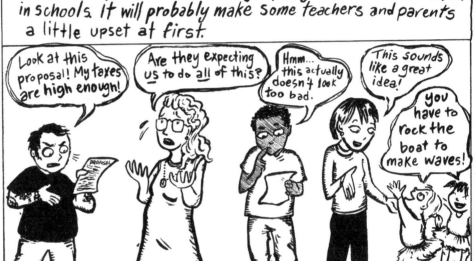

and it will require some **shifting** in policy and some **discomfort** in schools. It will probably make some teachers and parents a little upset at first.

Look at this proposal! My taxes are high enough!

Are they expecting <u>us</u> to do <u>all</u> of this?

Hmm... this actually doesn't look too bad.

This sounds like a great idea!

You have to rock the boat to make waves!

But you and I both know that **change** is a necessary part of **life**!

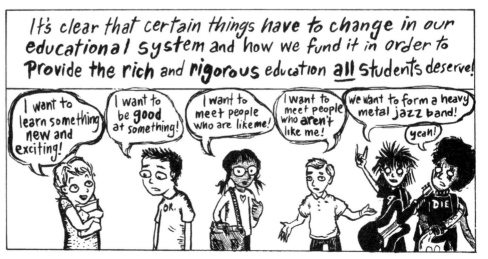

It's clear that certain things **have to change** in our educational **system** and how we fund it in order to **Provide the rich** and **rigorous** education <u>all</u> Students deserve!

I want to learn something **new** and exciting!

I want to be **good** at something!

I want to meet people who are **like** me!

I want to meet people who **aren't** like me!

We want to form a heavy metal jazz band!

yeah!

The kinds of adjustments I've brought up exist at many levels, in and out of government control; it would be foolish to believe that one branch of government could implement everything in whole-system reform.

Therefore, it is essential for non-government/independent organizations to help bridge some of these gaps, and for the government to help partnerships with these organizations **grow.**

Government needs to help regulate available resources equitably, and prevent frivolous spending and personal agendas from **taking over the** goal of an excellent education for **all!**

THIS IS A TEAM EFFORT

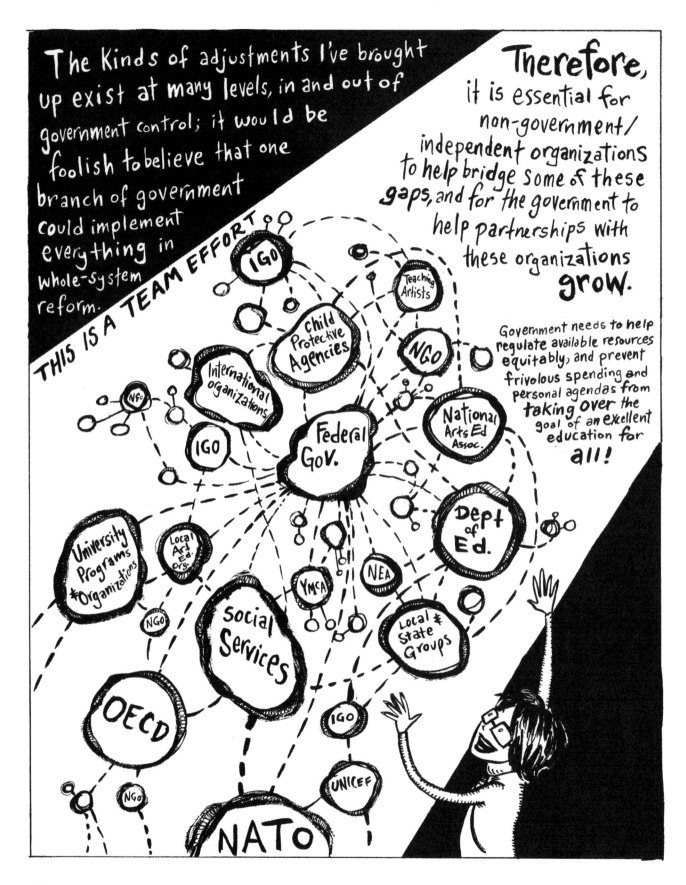

Here's my wish for **public education**: visual, performing, and technical arts at **every** school, for **every** grade, for every year of school, taught by teachers who are well-trained and taken care of, AND a strong platform for ELO's for outside-of-school learning.

And the **abolishment** of standardized testing.

And everything would be funded in a way to create **equitable educational** opportunities for **every** child, in **every** neighborhood across the country.

And for a crayon color to be named after me. Is that so much to ask?

Admittedly, it will take time and sensitivity to adopt any **number** of reform efforts, especially in **art** education. But I know if any of these changes are fully implemented, the results would be life-changing. Literally.

Except for the crayon thing. That would just be sweet.

"What happens is that [parents] don't necessarily see children as creative, nor do they think that they can learn through play.... These are facts, perceptions, and attitudes that make it hard to innovate."

37

Hard, but **not** impossible!

EPILOGUE

When I was a student at RISD, I heard Harry Belafonte give a talk called "Artist as Activist."

It was inspiring, hearing Mr. Belafonte reflect on his life as an artist, and his participation in social justice movements. He talked about action and standing up for what you believe in.

He talked about being motivated to organize, to act, to speak out. He talked about COMMUNICATION...

...yeah, COMMUNICATION!

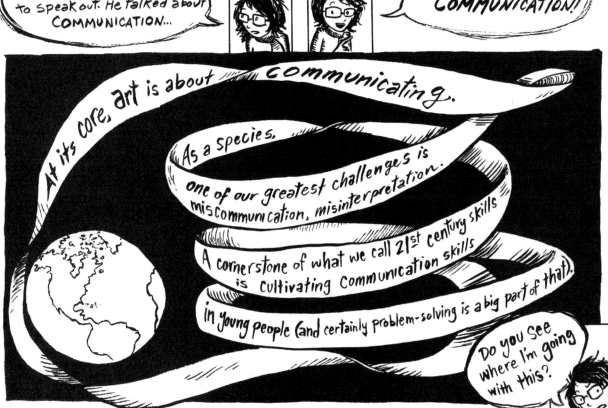

At its core, art is about communicating.

As a species, one of our greatest challenges is miscommunication, misinterpretation.

A cornerstone of what we call 21st century skills is cultivating communication skills in young people (and certainly problem-solving is a big part of that).

Do you see where I'm going with this?

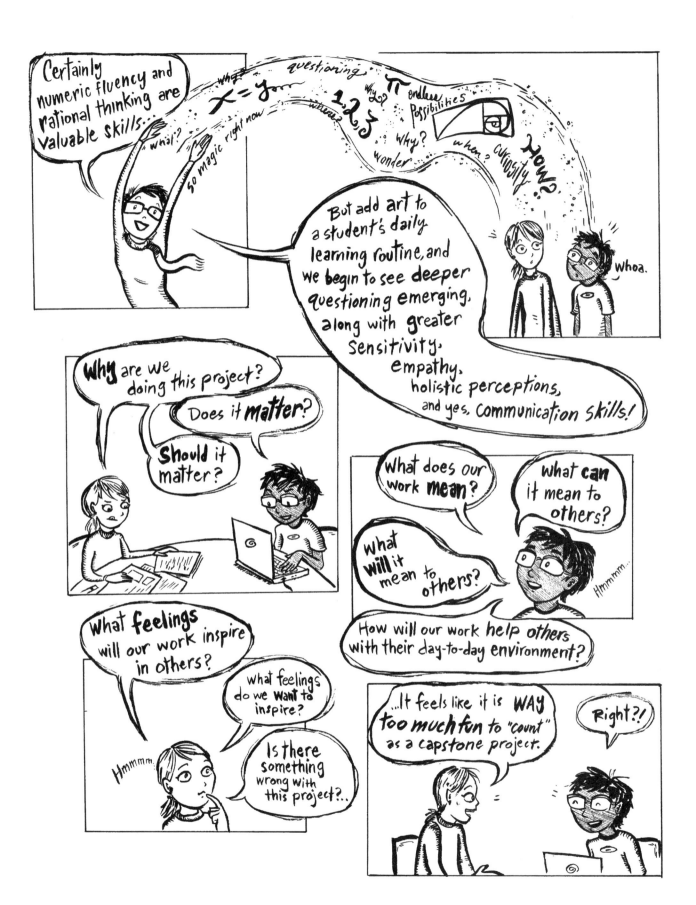

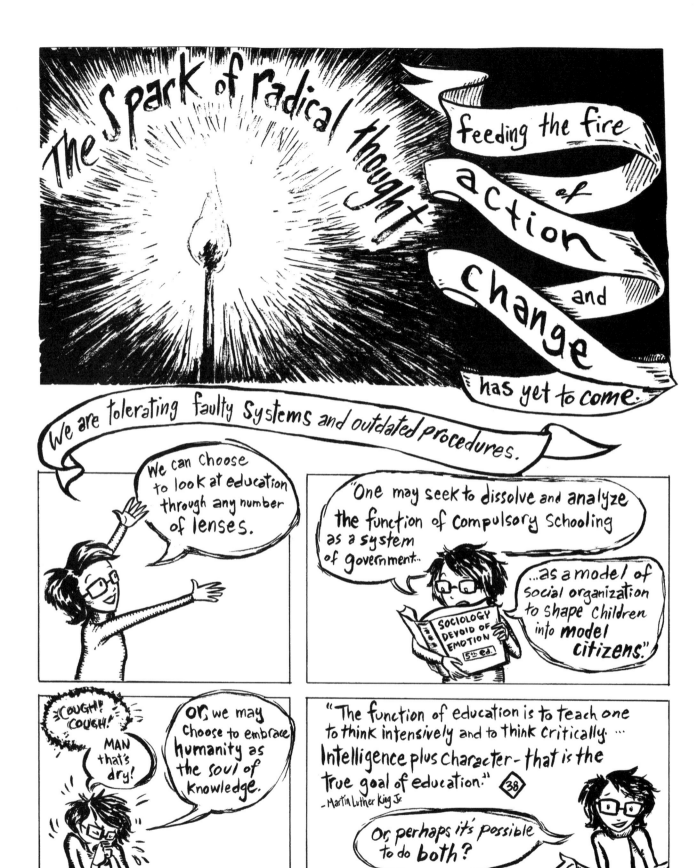

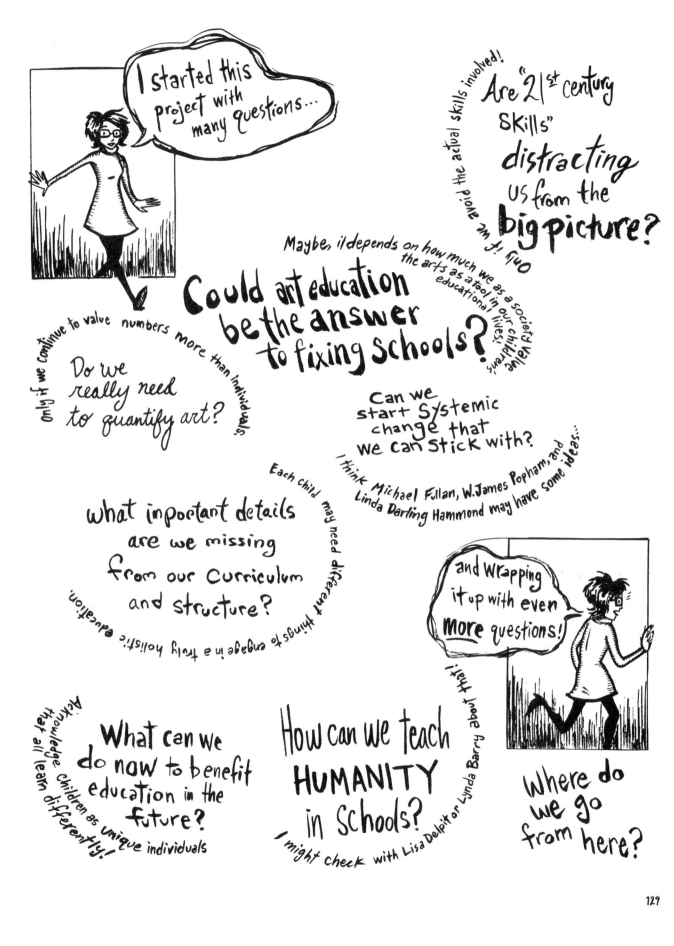

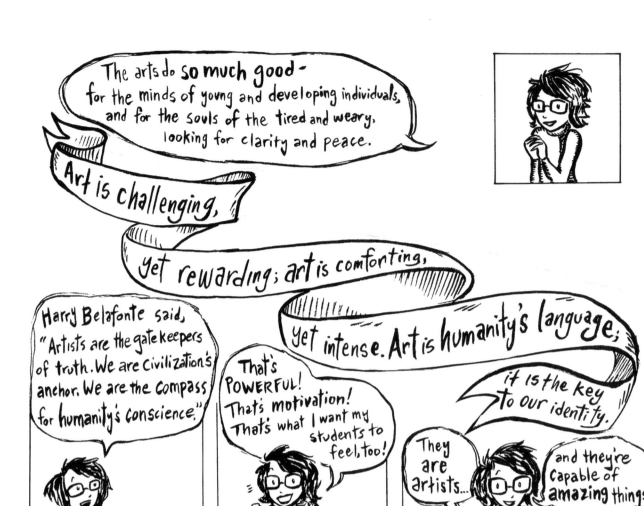

The arts do **so much good** — for the minds of young and developing individuals, and for the souls of the tired and weary, looking for clarity and peace.

Art is challenging,

yet rewarding; art is comforting,

yet intense. Art is humanity's language;

Harry Belafonte said, "Artists are the gatekeepers of truth. We are civilization's anchor. We are the compass for humanity's conscience."

That's POWERFUL! That's motivation! That's what I want my students to feel, too!

it is the key to our identity.

They are artists...

and they're capable of **amazing things.**

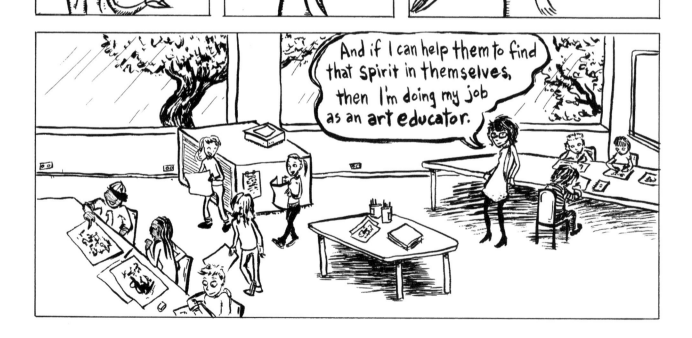

And if I can help them to find that spirit in themselves, then I'm doing my job as an **art educator.**

Notes

1. Dissanayake, E. (1992). *Homo Aestheticus: Where art comes from and why.* Seattle, WA: University of Washington Press.

2. Dissanayake, E. (1995). The pleasure and meaning of making. *American Craft, 55,* 40-45.

3. Efland, A. (1990). *A history of art education: Intellectual and social currents in teaching the visual arts.* New York, NY: Teachers College Press.

4. Lowenfeld, V. (1947). *Creative and mental growth.* New York, NY: Macmillan.

5. Brown, S. (2011). The doodle revolutionary's manifesto. Retrieved from sunnibrown.com/doodlerevolution/manifesto/

6. Barry, L. (2008). *What it is: The formless thing which gives things form.* Montreal, Quebec: Drawn and Quarterly, p. 103.

7. Barry (2008), pp. 51-52.

8. Innovate [Def. 1]. (n.d.). In *Merriam Webster Online.* Retrieval from www.merriam-webster.com/dictionary/innovate.

9. Johnstone, A., & Terzakis, E. (2012). Pedagogy and revolution: Reading Freire in context. In J. Bale & S. Knopp (Eds.), *Education and capitalism: Struggles for learning and liberation.* Chicago, IL: Haymarket Books, p. 189.

10. Taylor, K. (2012). Focus on: The Freedom Schools. In J. Bale & S. Knopp (Eds.), *Education and capitalism: Struggles for learning and liberation* (pp. 211-215). Chicago, IL: Haymarket Books.

11. Eisner, E. (2004). The roots of art in schools. In E. Eisner, W. Elliot, & D. Michael (Eds.), *Handbook of research and policy in art education.* London, UK: Routledge.

12. Sarason, S. (1990). John Dewey's *Art as Experience.* In *The challenge of art to psychology.* New Haven, CT: Yale University Press.

13. Massachusetts Department of Elementary and Secondary Education. (1999, November). Massachusetts arts curriculum framework. Retrieved from www.doe.mass.edu/framework/arts/1099.pdf

14. Massachusetts Department of Elementary and Secondary Education. (1999, November).

15. Common Core State Standards Initiative. (2016). English Language Arts anchor standards, College and career readiness anchor standards for literacy. Retrieved from www.corestandards.org/ELA-Literacy/CCRA/L/

16. Popham, W. J. (2008). *Transformative assessment.* Alexandria, VA: Association for Supervision and Curriculum Development, p. 6

17. Massachusetts Department of Education. (2007, February). MCAS guide to history and social studies assessments. Retrieved from www.doe.mass.edu/mcas/testadmin/hssguide.pdf

18. Fullan, M. (2011, April). *Choosing the wrong drivers for whole system reform* (Centre for Strategic Education, Seminar Series No. 204). East Melbourne, VIC: Centre for Strategic Education.

19. Tyson, N. D. (2013, April 14, 2:59). Twitter: neiltyson

20. Turnbull, A., Turnbull, R., Wehmeyer, M. L., & Shogren, K. A. (2016). *Exceptional lives: Special education in today's schools* (8th ed.). Boston, MA: Pearson.

21. National Center for Education Statistics. (2015, May). Youth and children with disabilities. Retrieved from nces.ed.gov/programs/coe/indicator_cgg.asp

22. Autism Self Advocacy Network. (n.d.). What is autism? Retrieved from autismadvocacy.org/home/about-asan/about-autism/

23. Pew Research Center: Social and Demographic Trends. (2015, December 9). The American middle class is losing ground: No longer the majority and falling behind financially. Retrieved from www.pewsocialtrends.org/2015/12/09/the-american-middle-class-is-losing-ground/

24. Meyer, J. W., Boli, J., & Ramirez, F. O. (1985). Explaining the origins and expansions of mass education. *Comparative Education Review, 29,* 145-170.

25. BoostUp. (2011). National dropout rates. Retrieved from boostup.org/en/facts/statistics

26. Delpit, L. (2006). Other people's children: Cultural conflict in the classroom. New York, NY: The New Press.

27. hooks, b. (2000). Feminist theory: From margin to center. London, UK: Pluto Press.

28. Delpit (2006), p. 39.

29. Passel, J.S., & Cohn, D. (2008, February 11). U.S. Population Predictions: 2005-2050. Washington, DC: Pew Research Center.

30. Frenemy [Def. 1]. (n.d.). In Merriam Webster Online. Retrieved from www.merriam-webster.com/dictionary/frenemy

31. The Institute for College Access and Success. (2015, October). Student debt and the class of 2014. Retrieved from ticas.org/sites/default/files/pub_files/classof2014.pdf, p.2

32. Denhart, C. (2013, August 7). How the $1.2 trillion college debt crisis is crippling students, parents, and the economy. Retrieved from www.forbes.com/sites/specialfeatures/2013/08/07/how-the-college-debt-is-crippling-students-parents-and-the-economy/

33. Johnstone & Terakis (2012), p. 189.

34. Sahlberg, P. (2015). Finnish Lessons 2.0: What can the world learn from educational change in Finland? (2nd ed.). New York, NY: Teachers College Press, pp. 198-200.

35. Tucker, M.S. (Ed.). (2012). Surpassing Shanghai: An agenda for American education built on the world's leading systems. Cambridge, MA: Harvard Education Press.

36. Arts Education Partnership. (2015, March). The arts leading the way to student success: A 2020 action agenda for advancing the arts in education. Retrieved from aep-arts.org/wp-content/uploads/AEP-Action-Agenda-Web-version.pdf

37. Howard, R. (2009). Education reform, indigenous politics, and decolonisation in the Bolivia of Evo Morales. International Journal of Education Development, 29, 583-593.

38. King, Jr., M.L. (1947). The purpose of education. The Maroon Tiger [Morehouse College Student Paper]. Retrieved from www.drmartinlutherkingjr.com/thepurposeofeducation.htm

Suggested Reading

Barry, L. (2014). Syllabus: Notes from an accidental professor. Montréal, ON, Canada: Drawn & Quarterly.

Darling-Hammond, L. (2010). The flat world and education: How America's commitment to equity will determine our future. New York, NY: Teachers College Press.

Freire, P., & Horton, M. (1990). We make the road by walking: Conversations on education and social change. Philadelphia, PA: Temple University Press.

Greene, M. (2001). Variations on a blue guitar: The Lincoln Center Institute lectures on aesthetic education. New York, NY: Teachers College Press.

Pence Turnbull, K.L., & Justice, L.M. (2012). Language development from theory to practice (2nd ed.). Upper Saddle River, NJ: Allyn & Bacon.

Radziwill, N.M., Benton, M.C., & Moellers, C. (2015). From STEM to STEAM: Reframing what it means to learn. The STEAM Journal, 2(1), Article 3. DOI: 10.5642/steam.20150201.3. Retrieved from scholarship.claremont.edu/steam/vol2/iss1/3

About the Author

Rachel Branham is an artist educator living in Massachusetts. She received her Bachelor's in Art Education from The Ohio State University, and her Master's in Art Education from the Rhode Island School of Design. Ms. Branham has taught a wide range of learners in diverse settings, but especially enjoys teaching students about comics. She also enjoys cooking, horror movies, and spending time with her husband Ben and their two pets, Psychobilly Freakout the cat and Momo the dog.